# CAPTURING
# LIGHT
*in Oils*

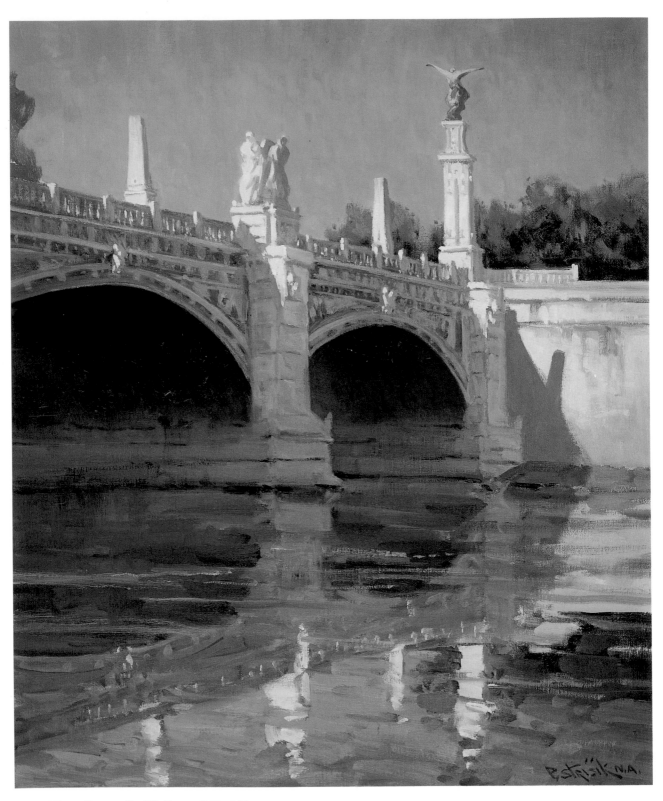

Ponte Victor Emanuelle, III, Rome, 24″ × 20″

# CAPTURING
# LIGHT
## *in Oils*

## Paul Strisik N.A.

**NORTH LIGHT BOOKS**

Cincinnati, Ohio

## ABOUT THE AUTHOR

Paul Strisik lives in Rockport, Massachusetts. He paints full-time and frequently travels in the United States and abroad to enjoy the challenge of new subjects. He works in both oil and watercolor, and is a dedicated plein air painter.

Strisik is a nationally acclaimed painter, an Academician (N.A.) in the National Academy of Art, and member of many prestigious organizations, such as the National Academy of Western Art, American Watercolor Society, Oil Painters of America, the Hudson Valley Art Association, and many others.

Strisik has had numerous one-man shows and has won more than 165 awards. His paintings are in many museums and prominent collections, and he has been the subject of articles in several publications.

Unless otherwise specified, all paintings in this book are oils.

**Capturing Light in Oils.** Copyright © 1995 by Paul Strisik, N.A. Printed and bound in Hong Kong. All rights reserved. No part of this book may be reproduced in any form or by any electronic or mechanical means including information storage and retrieval systems without permission in writing from the publisher, except by a reviewer, who may quote brief passages in a review. Published by North Light Books, an imprint of F&W Publications, Inc., 1507 Dana Avenue, Cincinnati, Ohio 45207. 1-800-289-0963. First edition.

99  98  97  96  95      5  4  3  2  1

**Library of Congress Cataloging-in-Publication Data**

Strisik, Paul.
Capturing light in oils / Paul Strisik. — 1st ed.
   p.  cm.
   Includes index.
   ISBN 0-89134-592-2
   1. Light in art. 2. Painting—Technique.
  I. Title.
ND1484.S77  1995
751.45—dc20          94-30895
                    CIP

| METRIC CONVERSION CHART | | |
|---|---|---|
| **TO CONVERT** | **TO** | **MULTIPLY BY** |
| Inches | Centimeters | 2.54 |
| Centimeters | Inches | 0.4 |
| Feet | Centimeters | 30.5 |
| Centimeters | Feet | 0.03 |
| Yards | Meters | 0.9 |
| Meters | Yards | 1.1 |
| Sq. Inches | Sq. Centimeters | 6.45 |
| Sq. Centimeters | Sq. Inches | 0.16 |
| Sq. Feet | Sq. Meters | 0.09 |
| Sq. Meters | Sq. Feet | 10.8 |
| Sq. Yards | Sq. Meters | 0.8 |
| Sq. Meters | Sq. Yards | 1.2 |
| Pounds | Kilograms | 0.45 |
| Kilograms | Pounds | 2.2 |
| Ounces | Grams | 28.4 |
| Grams | Ounces | 0.04 |

*For my wife, Nancy*

*A special appreciation to my good friend Charles Movalli for his invaluable advice and help.*

# TABLE OF CONTENTS

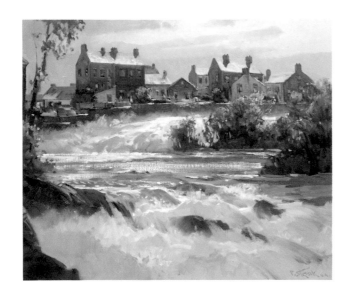

# INTRODUCTION

Paintings have fascinated me for as long as I can remember. When I was eight or nine, one of my playmates lived in a house with fine paintings on the walls. At that time, paintings were not seen in homes as often as they are today, and I can still remember how impressed I was. There was a magic in those paintings that completely enveloped me. I can also recall having seen artists painting the Italian fishing fleet near my home at Sheepshead Bay, New York, when I was young. Spellbound, I'd watched them by the hour. Later on, I haunted the halls of the Brooklyn Museum; whenever I smelled turpentine, I would make a beeline for the busy copyists, whom I loved to watch. In those days, I had all sorts of interests, from photography to gemstone cutting, and I mastered most of these hobbies fairly well. But as soon as I started painting, I saw that it could *never* be mastered. It was more than a pastime. It was a profession—a profession of great responsibility and dignity.

My first teacher was a noted abstract painter who stressed personal expression over everything else. I was unhappy during this period because I didn't see how his approach could ever lead me to the kind of painting I most admired in the museums. I once asked the teacher if I shouldn't at least be *able* to do a traditional portrait or landscape, even though we were working abstractly. He told me that *not* knowing how to do such things was an advantage: I had fewer conventions to "unlearn." He believed that academic training got in the way of self-expression.

At this critical time in my student life, I met Frank Vincent Dumond, a man of compassion and philosophy, at the Art Students League, New York City. When I joined his class, painting finally began to make sense to me. It's hard to explain the influence of a great teacher, for although Dumond's class was devoted to painting, he hardly ever talked about it in the cut-and-dried manner that every fact-starved student desires. Whenever I asked a technical question, he'd reply in a very abstract, philosophical way. Yet he *was* answering me. He tried to orient his students' minds so we would someday be in a position to get answers on our own. He wanted us to use more than our eyes. He made us analyze nature so we could paint it without resorting to formulas. He stressed cause and effect: If you understand the cause, you can paint the effect with greater insight.

Later on, when I began teaching art myself, I realized that the most a teacher can do is give a student a better understanding of what good painting is all about. In business, the employer tells a new employee his duties, but the employer can't stand next to the employee all day long. If the employee is smart, he'll soon see ways the job can be done more easily and efficiently. Innovations spring from his own ingenuity. That's the case with all good students, too.

Eventually, I stopped teaching because I couldn't say everything that I felt needed saying. At first, teaching was easy. I felt I knew what painting was all about. But the more I worked and thought about painting, the more complicated the subject became. I began to question much of what I had previously taken for

*Annisquam River,* 18″ × 20″

granted, and it became impossible for me to convey this complexity to my students. Whenever I tried, I felt the students were anxious for me to stop "philosophizing" and to get down to explaining how to paint a tree or a rock. I understood the feeling, for I had felt much the same way when I listened to Dumond's long, involved lectures.

In writing this book, I'm not as rushed as I'd be if I were giving a two-week workshop; I can take time to talk about matters that are important to me. It would be easy for me to be dishonest and just give you a lot of technical tricks, but that would have nothing to do with art. Jay Connaway, the marine painter, once criticized a student's work by telling him that his technique was good enough to paint a masterpiece; he meant that his manual dexterity was ahead of his conceptual development. Technique is like language. A man could speak perfect English but have nothing to say, while someone else—an immigrant, for example, who spoke broken English—could have wisdom in every word. The artist's real contribution is the expression of his own reactions to the world around him. It is my hope that what I have to say in these pages will help you develop your artistic and conceptual awareness as well as your painting methods.

I believe it's best to begin painting with oil or acrylic rather than watercolor. When you learn to sculpt, it's better to start with clay than with granite so you can correct your mistakes and thus come closer to your intention. So it is with painting. Oil paint is a malleable medium and allows you to make changes as you work. I feel I can get a better sense of students' abilities by looking at their work in oil. They've worked and reworked the canvas till they feel they've come as close as possible to their intention. Watercolor can be scrubbed and sponged out, of course, but it has its limitations. It can run away with you, and you often have to be content with mistakes that do not show what you really intended to say.

Later on, as you get used to the various media, you'll find they aren't all that different. People talk about "watercolor subjects" and "oil subjects," but they mean that they see ways a subject can be handled using mannerisms peculiar to watercolor or oil. It's not a meaningful distinction. I use whatever is at hand to record my response to a scene. The choice of materials has nothing to do with artistic expression. An artist could paint a subject in watercolor, oil, acrylic or pastel; he could work smoothly or roughly, thickly or thinly. From a distance, each picture would have the same emotional impact; only when you got closer would you notice what materials were used. When we look at Michelangelo's work, for example, we never worry about his methods; we're too impressed by the way he makes us see and feel biblical events. He would affect us just as deeply if he had done his murals with a piece of coal on the side of a building. You can write a letter with a typewriter, a pencil or a crayon. What you have to *say* is the important thing.

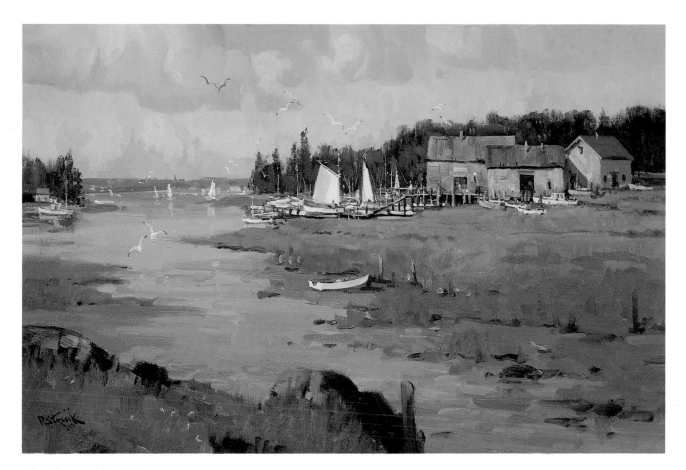

*The Marina,* 16″ × 24″

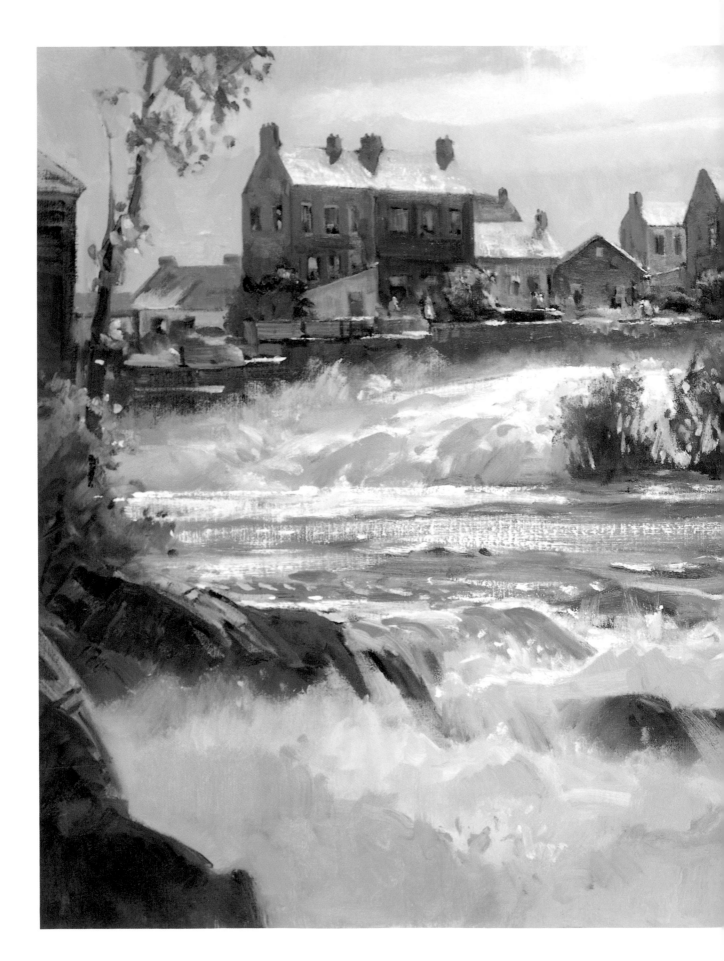

# PART ONE
# MATERIALS AND METHODS

The so-called secret of the Old Masters, whose canvases were engineered to last, was nothing more than a deep understanding of the materials of their craft. Painters today should also try to learn as much about their materials as possible.

But before discussing painting supplies, I want to talk for a minute about drawing. You should always have a sketch book with you. Draw constantly—until you begin to love it. Drawing is understanding. You work slowly and get at the nature of the subject. When you paint, a few quick strokes can easily suggest an effect. But when you draw, you can take time to live with your subject. If you have trouble drawing a dory, for example, take a sketch pad to the waterfront and spend a day drawing one as it changes position in the water. By the end of the day, you'll have a firm knowledge of the character of dories and rowboats. A minute spent drawing is never wasted. Even quick notes are helpful because they reveal the way you think.

*Ennistymon Falls, Ireland,* 24″ × 30″

## DRAWING MATERIALS

You can draw with a pencil, soft charcoal or a felt-tip pen. Use the tools you find most comfortable. I tend to be too careful with the pencil. I like to work in large masses, as a painter does, and haven't the patience to build up my darks with repeated strokes of the pencil. I therefore prefer a thick, soft lead pencil, which can indicate design and masses quickly in a painterly fashion.

## BRUSHES

Prior to World War II, bristle brushes were a joy to use. The bristles were full and firm, kept their shape, and lasted a long time. However, they have been deteriorating in quality ever since. So we must make do with what is available. In this respect, purchase the best brushes obtainable on today's market. They should keep their shape with use and wear evenly.

You should select the type of brush that best suits your way of working. My brushes are both flats and brights, with some small no. 3-4 filberts for finer lines. Occasionally I use long-hair sable riggers but only on smaller paintings. When I work outdoors, I may use as many as seven or eight brushes, keeping those I use for my darkest tones isolated so they don't become contaminated with lighter colors. In the studio, however, I use fewer brushes since I can clean them as I work.

### Cleaning Brushes

I always use kerosine to wash my brushes. It doesn't evaporate, and it leaves the brushes soft, while coating them with a slight film of oil, which was a natural condition when they were on the hog. Turpentine and mineral spirits do a good cleaning job, but they evaporate from the container into the studio, have strong odors, and make the bristles brittle. Soap and water may make the brushes look cleaner, but they really aren't. And the scrubbing process also takes too much time and effort.

I punch holes in the bottom of a small can with a large nail or punch and then place it inside a large juice can filled with kerosine. When I clean my brushes, the sediment falls through the perforations to the bottom. The holes in the smaller can treat the bristles more gently than the sieves that some people use. When the bottom of the contraption is finally filled with sediment, I throw it away and make myself a new one.

### Repairing Brushes

When the ferrule of your brush becomes loose, don't crimp it with a pair of pliers. It'll simply wiggle in a different direction. You can buy a stick of ferrule cement at any fishing-tackle shop. First remove the handle. Then use a candle to melt the cement onto the brush, warm the ferrule itself and insert the handle.

*Pencil Sketch*
This is a drawing made as a reference note for a painting. Notice how the thick, soft lead lends itself to designing large masses quickly.

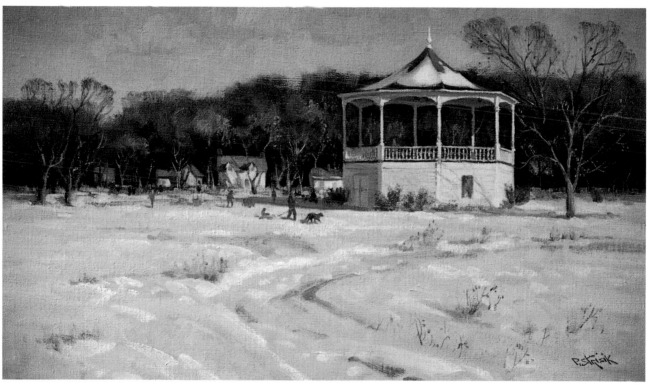

*The Bandstand, 12″ × 20″*
The town bandstand is usually associated with the summer season. Painting it in a winter setting gives it a new and different mood. I may use as many as eight brushes when I work outdoors, keeping separate the ones I use for darker tones and those for the light notes.

*Taboret*
A used chest or table can double as a cheap and convenient taboret. The taboret I use now (right) is an apothecary chest that I customized. It holds my wood palette, brushes and mediums.

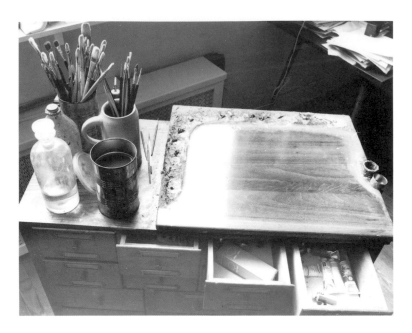

*Old Truchas,* 12" × 24"
Here are some old adobes and buildings in northern New Mexico. I am looking into the afternoon sun, which strikes the roofs and flat planes with a sparkling light. The general effect is one of strong contrast and light, and the warm colors of the buildings and grasses add to the luminosity.

## PALETTE KNIFE

A few touches with a palette knife can be useful when you paint, but don't use it to excess. Your pictures will have a mannered look, with heavy paint ridges taking precedence over your subject matter. In my opinion, palette-knife painters usually do their best work *in spite of* the knife, not because of it. I use it mainly when my paint becomes thick and unmanageable. It's better to scrape it off and try again than to throw good paint after bad.

## PALETTE

I use a 20″ × 24″ cherry-wood palette on my taboret. The size of your palette depends on your own preference, but I don't recommend getting one any smaller than 16″ × 20″. I don't like white palettes, particularly outdoors, because they catch the light and reflect it into your eyes. The white palette also weakens values, since almost any color looks dark when judged against it. My cherry-wood palette is a nice middle tone and makes a good background for judging color. I also like a wooden palette because wood is warm and keeps your colors from becoming too cool. You can't help but judge the warmth or coolness of a mixture by its surroundings. On a warm wooden palette, yellow or orange doesn't look as warm as it does on a blue-gray palette. Therefore, you will tend to mix slightly warmer colors, and that warm bias will add to the luminosity of your painting.

I clean my palette after every day's work. If you're lazy, you can use Formica or glass and scrape the dried paint off with a razor blade. Both glass and Formica palettes are good. But I like natural materials, and every time I clean my wood palette, I feel I'm adding to its rich patina. It appeals to me in an aesthetic way. If you also like natural palettes, cut a piece from birch or maple plywood, and seal it with linseed oil so the paint won't stain too deeply. You can also seal the palette by coating it with shellac, allowing it to dry, and then sanding the surface with steel wool (using machine oil as a lubricant to avoid excessive abrasion).

## TABORET OR PALETTE STAND

You can buy specially made taborets, but it's easier and less expensive to get a washstand, a side table, or any kind of small chest from a used-furniture store. My first taboret was a cheap piece of pine furniture. Now I use a small apothecary chest. I added large casters and put a piece of easily cleaned Formica on the top. My wood palette rests on one side, and the remaining space holds brushes, a can of kerosine, medium and other miscellaneous materials. Paint tubes are stored in the drawers.

## EASEL

My studio easel is an old, large traditional type made of oak, with a crank to raise and lower the canvas. If your studio is a permanent one, a good studio easel is an asset; otherwise, the portable French easel-box is quite satisfactory.

## PAINTING SURFACES

Painting surfaces vary in quality (some are fine for student work, but not for professional purposes) and have different characteristics. Often, the material you choose—whether it be linen or cotton canvas, Masonite or Upson board—is a matter of personal preference, but it's important to know about its properties and how to prepare the surface for oil painting.

### Linen vs. Cotton

There's nothing wrong with cotton canvas, as long as it's a high-grade, tightly woven sailcloth. Colonial painters used cotton canvas. However, most cotton canvas today is an economy product: It's loosely woven, with little tensile strength and an unpleasant "feel" when you work on it. Some cotton canvas is so weak it can't be used for large paintings; the weight of the paint hanging on a large canvas will eventually pull the material apart. If you do decide to use a high-quality cotton canvas, run your hand over it before starting to paint. It will probably feel rough, the cotton fibers having been hardened by the glue sizing. You should go over it very gently with a piece of fine sandpaper, but don't overdo it.

Many artists prefer linen to cotton. There's nothing like the luxurious feel of traditionally manufactured linen, especially that made in Belgium. I prefer a fine weave; rough canvas is hungry for paint and swallows it up. However, it is fine for larger work. A smoother surface will also give your pictures a more brilliant, enamel-like look. The tooth is less noticeable and doesn't attract attention to itself.

When I get a roll of canvas, I saw through the entire roll with a band saw to cut it into convenient lengths for painting. The large roll is 84 inches long. I cut it into 23-inch, 27-inch and 34-inch lengths. I use the 23-inch roll when I'm stretching any canvas with a 20-inch dimension. The 27-inch roll yields all my 24-inch sizes. And the remaining 34-inch roll takes care of my 30-inch canvases. If your canvas comes in shorter rolls, you can easily figure the best way to cut it. This simple procedure greatly facilitates the cutting and stretching process.

### "All-Purpose" Canvas

When working in oils, you should beware of the popular "all-purpose" canvases. Preprimed with acrylic, these canvases are supposed to be compatible with either oil or acrylic paints. Yet in the opinion of many experts on paint chemistry, you should *never* use oil paint on any surface—canvas, Masonite, Upson board or any other material—that has been primed with acrylic or any other nonabsorbent material.

Acrylic and oil paints are completely different mediums. To adhere to a canvas, oil paint needs to sink roots into the primer. It can't do that with acrylic; it just sits on the surface. In addition, the acrylic primer remains flexible long after oil paint has become hard as nails. The different rates of contraction and expansion will, in time, crack and separate the oil layer.

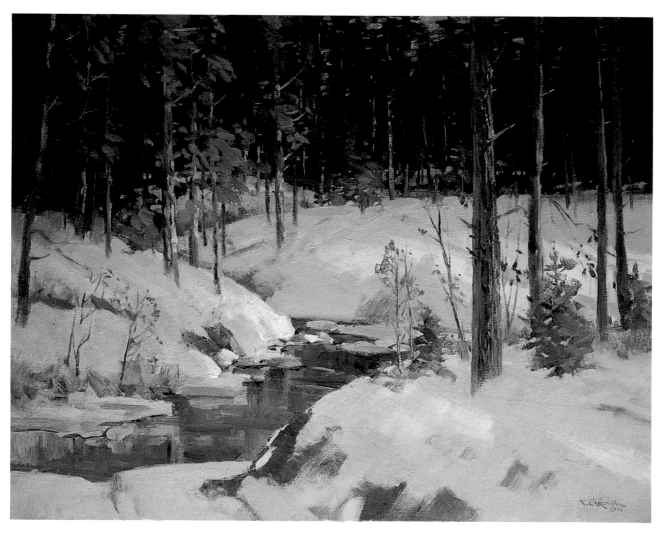

*Winter Stream,* 24" × 30"

In this scene, painted on canvas, the snow shadows are kept light and luminous, affected by reflected light from the sky and sunlit portions of the snow.

***On Galway Bay, Ireland,*** *16″×20″*
This piece, painted on Masonite, was done on a clear morning. The flat, bright sunlight gave a colorful sparkle to this scene. The kelp in the low-tide foreground was a rich dark warm reddish violet, which created a wonderful contrast to the sunny areas.

The reason acrylic-primed canvas is so popular is that manufacturers find it convenient and economical. The old-fashioned method—sizing the canvas fabric with glue to prevent rotting and then covering it with an oil-based white paint—is more time-consuming and costly to produce. Canvas can be quickly coated with acrylic gesso, and the product can be packaged within hours.

## Canvas Panels

Cardboard-mounted canvas panels are all right for the student, whose exercises aren't meant to be permanent, but not professional work. They have an unpleasant surface, and, more importantly, they're a commercially competitive product. Manufacturers turn them out cheaply and quickly, using thin canvas, inadequate priming, and inexpensive pulp boards so full of acid that they quickly deteriorate.

You can make much more durable panels yourself by mounting canvas to Masonite. You should first roughen the surface of the Masonite with extra-fine sandpaper. To attach the canvas, use either a white glue, such as Elmer's Glue-All, or the older Franklin Liquid Hide Glue. I prefer the hide glue. When you use synthetic glues like Elmer's, you have to weight down the panel till it dries. With hide glue, on the other hand, you squeeze a bit onto your sanded panel, spread it with a rubber linoleum-block printing brayer, and put the panel aside while you prepare two more. By the time you've done the third panel, the first is tacky and you can lay the canvas on it, smoothing it out from the middle with your hand to eliminate all air bubbles. No weighting is necessary. The panels may warp slightly immediately after you've finished, but they'll straighten out again when completely dry. You should be able to do fifteen or twenty medium-size panels in an evening, trimming the edges with a razor blade after they've dried. Since hide glue is water-soluble, the caked brayer is simple to clean. In addition, the water-solubility makes it easy for a restorer to remove the canvas, if necessary, in later years. The white glue is much harder to remove.

## Upson Board and Other Pulp Boards

Upson board and other pulp boards are good only for student work. You can prime them with a coating of dilute shellac (a five-pound cut) mixed with four or five parts alcohol. The shellac can also be used for priming pieces of all-rag mounting board for sketching purposes only.

Upson board became popular, and many artists worked on it. Unfortunately, like all cheap cardboard, the paper has sulfide in it and soon mixes with the moisture in the air to create sulfuric acid. The material literally burns itself up—a process that is accelerated in a damp climate. Older boards actually powder to the touch!

## PIGMENTS

I'm always hesitant to recommend specific colors. In the first place, pigments differ from brand to brand: One brand of cadmium red medium might be Winsor & Newton's cadmium red, Grumbacher's cadmium red deep, or some other maker's cadmium red light. I also dislike specifying a palette, since almost all manufactured pigments can have a legitimate function in a painting. I use a restricted, uncomplicated palette because it keeps me from getting lost in a rainbow of colors and leaves me free to concentrate on the more important aspects of painting: values, composition and the like. I use the same palette inside, outside, and on all my travels. However, if you stick with a palette for too long a period, there's always a tendency to favor certain mixtures. Even if a palette works for you, it's sometimes smart to substitute different colors for a few favorite pigments. You're forced to find new solutions to your problems and to learn more about color.

### My Basic Palette

My palette always includes at least these basic colors:
cadmium yellow pale or light
cadmium yellow deep
cadmium orange
yellow ochre
burnt sienna
cadmium red medium
ivory black
ultramarine deep
phthalo blue
titanium white

### Optional Colors

I add other colors as necessary:
raw sienna
alizarin crimson
terra rosa
chromium oxide green

I don't feel the greens are essential to have because the phthalo blue can make almost any green; however, some artists like viridian on their palette. For the violets I find that the blue and red, or alizarin, give me violet enough for my purposes.

If you are painting still lifes, and especially flowers, other colors may be necessary, such as ultramarine violet or the very strong dioxazine purple or other reds.

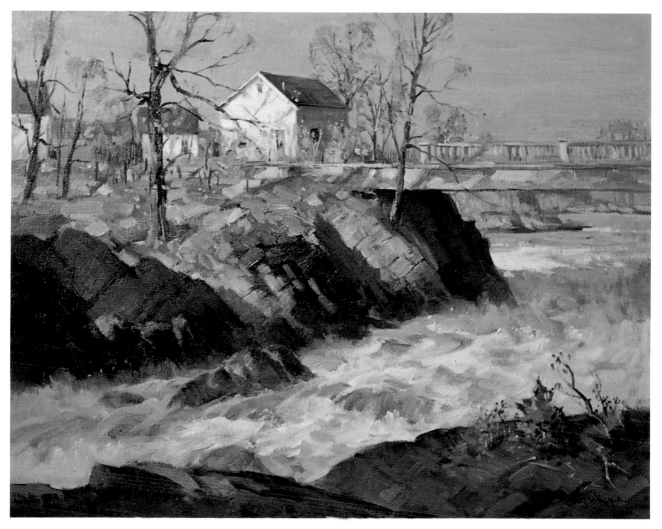

*Spring Rapids,* 24″ × 30″
In the spring the melting snows feed the streams until they are running full and lively. The new leaves are just beginning to show. I painted in a free manner using clear light colors, all enhanced by the rich darks in the rocks.

*Essex Spring,* 12″ × 16″

This is a painting of the Essex marshes on a warm spring day. The trees are showing new leaves, and the marshes still have winter color. If it were not for the welcome accents of the dark cedar trees and brilliant white notes of houses and boat, the scene would not be as lively.

## Black and White

Some painters don't use black, as they think it muddies color, yet I've seen plenty of "muddy" pictures painted without black. There's just as much life in a green-gray mixed by adding black and white to green as there is in a green-gray mixed with "pure" color. It's still green-gray, no matter how you get it. The main problem with black is a technical one. If you use lavish amounts of pure ivory black, for example, there's a chance of its cracking with age because of its high oil content. In that situation, I substitute Mars black, a stable iron oxide.

All whites are permanent, but I prefer titanium white because it works *with* me. Zinc white is more transparent, and you have to use lots of it. This is fine if you like heavy, impasto effects, but I don't paint that way. Nor do I find that zinc white makes cleaner tints than titanium, despite the claims of its admirers.

When I buy white paint, I also read the label to make sure it's ground in linseed oil. Many of today's paints are ground in safflower, a greasy oil that gives the paint disagreeable handling characteristics. Linseed oil also makes a tough and flexible paint film; it's the most durable of all the binders.

Of course, lead white is the best white of all. It's the color the Old Masters used; and if you look at their pictures, you'll notice that while other colors may have faded and cracked, the whites are still in good condition. Unfortunately, lead white is banned nowadays because of the danger of lead poisoning. That is a problem. Years ago, I saw a show devoted to nineteenth-century Italian painting. Of the thirty artists presented, four had died of lead poisoning. But I also noted that they'd been careless: One, for example, mixed paint on his forearm instead of his palette! He had adsorbed the lead into his system.

An aesthetic warning: Always think twice before using white. It can give your pictures a chalky look. If you want to lighten color, try using another color instead of white. If you want your paintings to have brilliance, think in terms of *more* color, not *lighter* color.

## "Hues" and Bariums

Avoid all "hues." When the tube says a color is a "cobalt blue hue," for example, this means the paint isn't cobalt blue at all; it was mixed to look like cobalt blue by using other colors. As a result, it won't act like cobalt blue when you use it in different mixtures.

I also prefer to buy pure cadmium colors instead of the cadmium-bariums. Barium won't affect the color quality; it's simply an inert extender, added to make the color go farther. You'll probably use three barium-extended tubes for every one of pure cadmium, but they are satisfactory for student use.

## Color Mixing

I can't teach you color; you have to learn about it by playing with the colors on your palette. However, here is a single exercise you can try: Mix two or three colors, add white, and draw them out on the palette in graduating values. It's amazing what you can learn from such a simple experiment.

I can give you a few practical pieces of advice about color mixing. First of all, put plenty of paint on your palette, and lay out all your colors when you paint, no matter how gray or colorless the scene appears. The palette is your keyboard, and it should have all the color notes, always arranged in the same order. Once the palette is set up, *use* the paint! Most students do little more than dirty their brushes with a little color and then try to wipe them off on the canvas. To mix color properly, you must have enough pigment on the brush in the first place. Use plenty of paint and you won't smudge areas together, thus giving your pictures a weak and indecisive look. Be prepared to wipe your brush every four to six strokes, and then pick up more paint. You'll soon learn that two-thirds of your pigment normally—and rightly—ends up on a rag, either from wiping the brush or from cleaning off your palette. You can see brass on the ferrule of a good painter's brush; he wears away the chrome through constant wiping.

When you mix colors on the palette, don't work in little spots; make big smears of color. If you discover that a green mixed from cadmium yellow and ultramarine blue needs to be warmer, don't put the extra yellow smack in the middle of the mix. It has to counteract all the original blue, and you'll need half a tube to change the color temperature of the mixture. It's much easier to add yellow to the *edge* of the color swatch, allowing the yellow to affect the mixture and also creating a smear of color that has variety within it: from a blue-green near the center to a yellow-green at the edge. The mix can yield useful colors in the future. Blending all your colors in the center yields a single flat, uninteresting tone; you may get the color you want, but it will be useful in only *one* part of your picture.

Remember, too, that you don't have to attract the viewer's attention by throwing your entire palette at the canvas. You can get a powerful effect by limiting your range and using only a touch of pure color. The mood of your painting should determine your color scheme. Bright color would be useful in a lyrical piece, such as a beach full of children, strollers on a sunny day, or a vase of flowers. However, in a picture of an approaching storm, you'd need elements that speak about the hard business of living. Cornwall, England, for example, is epic in character. When painting such a subject, you can't afford to get bogged down in "pretty" colors. That would contradict the subject's power and monumentality and would fight against your expressive purpose.

I once saw a portrait that was painted primarily with three pigments: yellow ochre, Venetian red and ivory black. The addition of a green tie gave the impression that it was full color. The painter suggested color instead of throwing raw contrasts at the viewer. Jay Connaway, the noted marine painter, often balked at pure color contrasts, noting that anybody could paint straight from the tube. He wanted to use a more elusive, personal sort of color.

You're not making a literal copy of the scene; *you* decide whether or not to use color. It's the painter's personal tastes that give a picture character and personality. Color, as such, can even be a distraction. You've probably seen pictures that get their "punch" from vivid complementary contrasts: yellow trees against a blue sky or red flowers against a green drape. But who can work for a man who yells all the time? Eventually, you stop listening. *Force* comes from the *suggestion* of power in reserve.

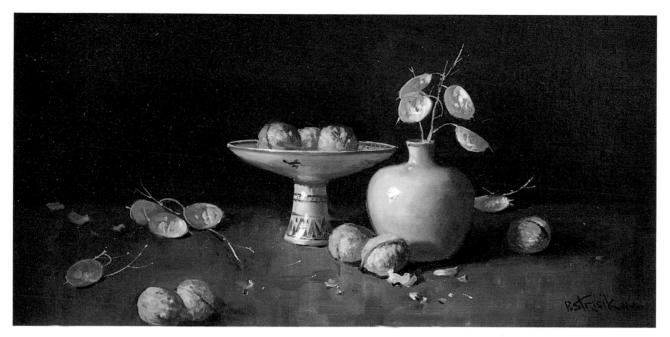

*Still Life With Walnuts,* 10" × 20"
This is a good example of an effective effort using limited color — just a few objects well composed against a rich, dark, warm background.

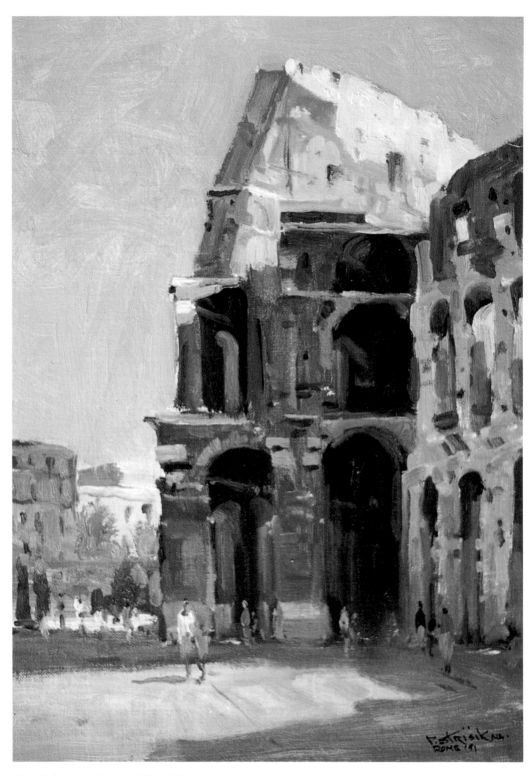

*The Colosseum, Rome,* 14″ × 10″

This was a most interesting subject from both a painting and a historical standpoint. The interesting shapes and dramatic contrast of light, shadows and textures were a pleasant challenge. It is a souvenir of my visit to Rome.

## MEDIUMS

I once asked an experienced picture-restorer at a museum which painting medium he thought held up best over the years. He recommended any medium with linseed oil in moderate proportions; it has proven to be a tough and permanent binder. It may yellow slightly, particularly when a picture's been stored in the dark. However, exposure to north light (not direct sunlight) for a few days will quickly bleach out most of the yellow. Of course, no medium is completely nonyellowing. No matter how careful you are, your pictures will "ivory" to some extent. This change isn't necessarily a fault; sometimes it unifies and mellows raw colors in a picture.

As long as there have been painters, there has been argument over the "best" medium. There is no ideal medium; each has its advantages and disadvantages. Since the troubles that befall a painting are largely due to problems with the binder, the medium is really a necessary evil. Most tube colors contain enough oil for direct painting, so medium should be used as sparingly as possible. One of the simplest and most popular mediums is that recommended by the chemist Ralph Mayer in *The Artist's Handbook of Materials and Techniques*, a book every painter should own. The medium consists of one part stand oil, one part Damar varnish (five-pound cut), and four to five parts turpentine. The varnish gives an added brilliance to the color, helps the pigment set up and facilitates paint handling. It also gives a "drag" to the paint so you don't slide all over the canvas. The turpentine makes it easier to mix paint and oil. Because it evaporates, it adds nothing to the final paint film.

Every painter has his favorite medium. I like Mayer's, but you may want to experiment and see what works best for you. Some painters prefer a "richer" medium — that is, a "fatter" one, with more oil and varnish in it; it gives pictures more of a gloss. But I can get the same effect by varnishing my pictures after they're done. However, I don't want to make any rules. Even if you do use my medium, you might want to use more or less than I do, and in the end, our pictures would still have different chemical structures.

There are only two basic rules you should heed in using a medium. First, you should always follow the time-tested practice of putting "fat" over "lean." Each successive paint layer should have at least as much oil as the one before it. Corrections made on a flat surface with a leaner turpentine medium, for example, will eventually crack. Second, you should avoid using too much medium as you work. Excess medium not only takes the life out of your color, but it also affects the longevity of the paint. In themselves, pigments are perfectly stable; it's the oil that yellows with age. So don't get into the habit of dipping into the medium cup with every stroke. The impressionists used paint straight from the tube, and I've been told that their pictures are the simplest of all museum paintings to clean and restore. A good conservator can make them look as bright and lively as they were the day they were painted.

## VARNISHES

I never use my varnish (Damar, five-pound cut) straight. I usually dilute it—half Damar and at least half turpentine. This mixture amounts to a "retouch" varnish and is useful when I work over a dried picture. A wet, glossy stroke applied over a dried, matte area looks darker, even though it's the same value. To judge values more accurately, painters spray such matte areas with retouch varnish. Some prefer to "oil out," rubbing medium over the picture surface, and it's the oil that yellows with age.

I also use the retouch mixture as a final varnish. Straight Damar would be too glossy; the picture would shine like a piece of glass. The final varnish protects the surface of the painting and makes the pigment look as it did when you first made the stroke. It gives it a fat, jewel-like appearance. I add seven or eight drops of stand oil to the varnish to increase its durability and to make it more flexible.

I don't like matte varnishes. The varnish has been weakened with adulterants to create the matte finish, and a weak film is not what a painter wants. Today there are a number of new acrylic varnishes on the market, but I've had little experience with them. Since they're said to be superior to the older varnishes, they'd be worth investigating.

### The Varnishing Process

For the sake of simplicity, I spray on varnish with an old-fashioned, breath-operated blower. These blowers are temperamental, but painters have used them for centuries. In addition, I can make my own varnish for this kind of sprayer; that way I'm sure of the quality and don't have to waste money on fancy packages and aerosol cans.

Books are full of "rules" for varnishing. You're told, for example, to work in a dust-free room and to wait at least six months before varnishing a picture. Such rules are leftovers from a period when pictures were very smoothly painted and artists used the unreliable mastic and other varnishes instead of Damar. A piece of dust caught on the glasslike surface of an Old Master painting would have been very obvious, but the same fleck of dirt on our rough paintings can hardly be noticed. Nor is it necessary to wait six months for a painting to dry. When using Damar retouch varnish, you can spray when the work is newly dry—though it's probably best to wait a week. However, if you're applying varnish with a brush, wait several weeks until the surface is thoroughly dry and can withstand the action of the brush.

After it's been varnished, a painting may have a few dullish areas. Don't worry about them. When painters worked smoothly, it was easy to put a faultless layer of varnish over them. Nowadays, however, we paint in a rougher manner. It's hard to cover such irregular surfaces—unless you load on so much varnish that the overall picture becomes much too shiny.

*Gull Cove,* 20″ × 16″
I have painted in this area for many years, but I always try to see subjects with a fresh viewpoint.
In this case I used a vertical format. I kept the foreground simple and increased the activity as I
neared the center of interest.

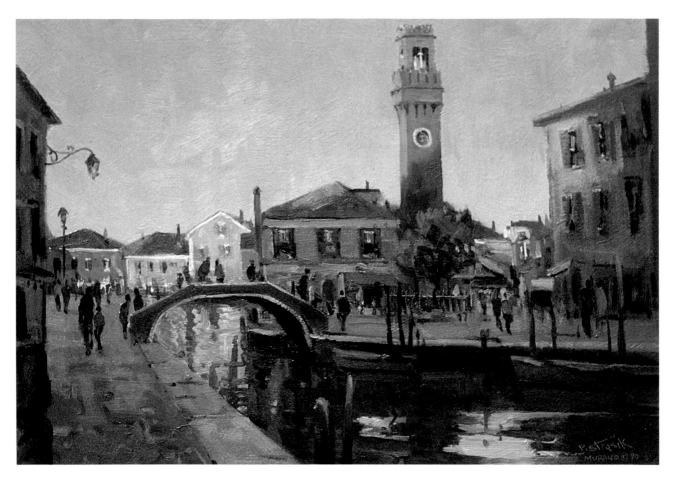

*Murano, Venice,* 12″ × 16″
I painted this in the late afternoon on a very clear day. The sun was setting, and the shadows from the buildings were changing fast. I only had time to lay in an 8″ × 10″ painting quickly, establishing colors and values. Later, back in my studio, I could paint unhurried, drawing on what I felt emotionally at the location.

*Sketch box*
Here you see me painting in Europe with a 10″ × 14″ sketch box, which I have fitted with a tripod socket and shoulder strap. Everything is self-contained and portable and perfectly suited for air travel.

## TRAVEL AND OUTDOOR PAINTING

I'm as comfortable working outdoors as I am in my studio. My equipment is designed for outdoor work, and I feel there's an excitement with painting on the spot that gives a painter's work the ring of truth.

At least once or twice a year, I take painting trips to explore new subject matter and paint on location. I sometimes fly, sometimes drive to my destination. When I fly within the country, I take a minimum of supplies because I know I can always buy additional materials. But when I leave the country, I take everything I need— and then some.

### Easels

When flying, I always carry the French easel-box; it's the ultimate in portability and convenience. It's been copied by Italian and American manufacturers, but the best is still the one imported from France. Lately, airlines have been restricting the size of carry-on luggage; after one trip, I was surprised to see my French box, its legs open, shooting down a luggage-conveyor belt. A solution to this problem might be to have a special suitcase built by a firm that specializes in salesmen's sample cases. You could even design built-in spaces to hold extra paints and equipment! Of course, you could also buy a cheap, standard-size suitcase just big enough to hold your easel securely.

### Sketch Boxes

When I drive or fly, I often carry small, self-contained sketch boxes. They're convenient, you can use them in cramped spaces, and they rest comfortably on your lap. Called "thumb boxes" or *pochade* boxes, they come in several sizes: 4″×6″, 5″×7″ and 8″×10″. The old-time painters always used such boxes. I recently made a new one measuring 8″×12″, which I consider a better proportion than 8″×10″. Or one can use a 10″×14″ or 12″×16″ sketch box fitted with a tripod socket. (See illustration on page 24.)

### Traveling With Canvas

When I fly, I precut a fine-weave, lightweight linen into pieces that fit the two or three stretcher sizes I carry with me. I either roll up the canvas or lay it flat in my suitcase. I stretch a few canvases the night before I paint. Since I use a lightweight staple gun, I can easily remove the canvases the next day and then stretch some more. Back home I can restretch the canvas or mount it on Masonite and continue working. I paint thinly when I travel, using a drop or two of cobalt linoleate drier in the white and the medium to ensure the picture will dry overnight. Cobalt linoleate is the only drier a painter should use; never use any of the progressive driers such as Japan drier, manganese drier, or any of the old-fashioned siccatives! A progressive drier, whose drying action continues over a long period of time, can eventually cause cracking and a variety of other defects in the paint surface. Cobalt linoleate is not a progressive drier and will not continue to affect your painting. If you're worried about the surfaces of your pictures sticking together when you pack, you can place sheets of waxed paper between them.

It's possible to carry as many as fifty small panels on a painting trip; they are lightweight and fit into a compact space. These are made by gluing fine canvas to thin "door skin" mahogany plywood, which is used to replace damaged hollow door surfaces. It's available at some lumber yards. It can be cut with a mat knife and metal ruler in two strokes.

## Cleaning Brushes

When I travel, I carry kerosine in a screw-top jar and pour it into a can when cleaning brushes after a day's work. I pour the mixture back into the jar when I'm finished. By the next day, the sediment, consisting mostly of heavy earths and metals (the cadmiums), has settled, and I can again pour off clean kerosine. When flying, any flammables are taboo, so I carry a bottle of detergent to wash brushes in my hotel room.

## Clothing

Outdoor painters have to be ready for all kinds of weather. I've painted in the freezing cold of the Canadian Rockies and in the heat of the Southwest. In Greece, I once worked in a deserted cafe, with an awning shading me from the sun and refreshing Greek coffee always ready.

As a general rule, you should wear dark clothing outdoors; it cuts down on the amount of light reflected off your body into the picture. On cold days, use insu-

***Sunday Morning, Estoril, Portugal,*** 15″ × 30″
I found the mood at this location to be one of a quiet Sunday morning. It was bright and sunny, and the sea was calm. The atmosphere was somewhat heavy, which accounts for the dark sky and reddish horizon. The touches of white add sparkle to the subject. The sailboats and figures convey a leisurely mood.

lated underwear, woolen pants, woolen stockings, ear muffs, galoshes that fit loosely (so they create an insulating air pocket) and inexpensive cotton gloves. A snowmobiler's jumpsuit is also supposed to be good protection. If you must wear dark glasses, use Tru-color, a neutral gray lens that won't distort the colors as most sunglasses do.

When you're properly dressed, you'll find that heat, cold or an awkward perch won't bother you; they're all part of the challenge. The only real irritants are the wind, tormenting and tugging at you like a great hand, and insects, buzzing and biting you. You can't do anything about the wind, but remember to add insect repellant to your painting gear.

*Miscellaneous Travel Equipment*

When painting in the snow, the old-timers used snowshoes and tarpaulins. I've even seen the equivalent of snowshoes for the legs of easels! I don't carry that much gear. But I'm ready for any emergency. One time when I was painting in the Rockies, I walked back and forth so much that the packed snow in front of my easel became as smooth as ice. Reaching for a brush, I slipped, grabbed the easel, and broke one of its legs. But it was a temporary tragedy. I was saved by the fact that I always carry a small tool kit containing pliers (to help with stuck tubes), wire, a knife, a file and epoxy cement. At the motel, I glued the leg back together and bound it with wire. The next day, the leg was stronger than before the accident.

## SUMMING UP

After all this talk about materials, let me repeat that painting is based on the concept and judgment of the artist—*not* on the artist's palette, medium or tools. A professional painter could apply mud to a wall with his thumb or with a brush held in her mouth and still get a good effect. It's the mind that makes the important decisions. The "rules" regarding materials are elementary:
1. Use a simple palette.
2. Use your medium sparingly, if at all.
3. See that all your materials are permanent and compatible with one another.

# PART TWO
# CONCEPTION AND COMPOSITION

In the previous chapter, I talked about the specific materials of the painter, and next I'll discuss some of painting's more mechanical aspects. Most students are deeply interested in these "facts" of the painter's craft. They want to know how to paint the details of a particular scene. Yet the scene itself, although it excites and inspires us, is only the beginning of the painting. It's the excuse for our making a personal statement about what we've seen and experienced. The *conception* of the subject is the important thing in art—that's the real measure of the painter. Composition, design and color come afterward. Detail is merely additional entertainment—good for when the viewer looks more closely at your picture.

When you arrive at a site, ask yourself, "What made me stop and look?" It sounds like a simple question, but once you answer it, you'll begin to understand the personal significance of the subject. A painting is often more exciting than nature because it's a distillation of the scene. It stresses the poetry and your sense of the subject. It's more truthful than "reality" because it's a frank expression of your feelings.

*The Shell Collectors*, 16″ × 24″

## A SENSE OF PLACE

When you stand before a subject and think, "Oh, that's beautiful," you're not responding to the details of the scene. You don't even see them when you have that initial thrill. You notice the details only after you open your sketch box and begin to paint. Your original conception didn't include an inventory of trivia. So why put such trivia into the picture?

Imagine a painter who sets up his easel and spends three weeks on a meticulous rendering of a small town. Another artist comes along, does a sketch in an hour and leaves. Both paintings are shown in the village, and our careful painter scoffs at the sketch: "It's not even the village," he might say. "He's left out the henhouse, heightened the mountain, and cut down the trees!" Yet the townspeople immediately identify with the sketch. One painter gave them a blueprint of the village; the other, a sense of place.

People aren't interested in blueprints; they want to sense the painter's involvement and pleasure in the subject.

The job of the artist, then, isn't to make blueprints. Many of the details you see at a given site are common to all scenes. They're not important to you unless they say something significant about your particular subject. Nature is a storehouse of material. The components of a picture are scattered helter-skelter, and you have to pick and choose among them. You have to give your conception the proper setting, just as you would set a diamond in a ring or arrange a group of actors so each has an appropriate place in a tableau.

### Facts

If facts were enough, you could take a photograph of the subject. Unlike the sensitive observer, however, the camera never selects or comments, never adds or subtracts. Think of all the disappointing slides you've taken on vacation. I often take slides myself, whenever I feel there's something valuable in the scene. Yet when I get them from the processor, I often have trouble remembering why I bothered to take them. The scene is there, but the emotion and excitement are absent!

Unfortunately, students often think they have to mimic the camera. They want to put in everything. They feel that the detail *is* the scene. They don't realize that no great painter has ever "copied" nature—if only because it's an impossible task.

That's one reason it's often valuable to work on a small scale, to capture just the basic landscape elements. The light in the sky is simply a few big strokes of the brush. I haven't room for superfluous detail—only for the big, simple units that first hit my eye: the sky, the dark trees, the snow. Further embellishments are best left for the studio.

### Description

I remember my teacher, Frank Vincent Dumond, telling me, "All the facts are accurately stated in your pictures, and I have to admit that you're a very truthful young man." I thought he was complimenting me. Then he said, "But you forget to include in your paint box the cement that holds all your facts together." I was painting a super-accurate description of the facts—at the expense of the whole idea.

Your eyes don't tell you what to paint; your mind and feelings do. But you don't have to do heroic exhibition pictures to make a personal statement. A small pear tree in your back yard can be an honest and moving subject for a painting because you have an affection for it. Such a picture may not set the world on fire, but the viewer responds to it because he feels you're sharing an emotion with him. Remember: Anyone can describe things, but there's a magic to what the inspired painter does. That's what gives the artist's profession its dignity and its almost religious character.

*Folly Cove,* 20″ × 24″
In order to express the character and strength of the New England coast, I used the granite rock forms in an almost symbolic way. This scene, as painted, does not exist; however, people have remarked that it looks familiar and ask where it was painted.

## COMPOSITION

The first question the painter asks himself is "What is there in this scene that interests me?" because the emotional response always comes first. If you were to place ten people in front of the same scene, they'd all see different things. An executive's thoughts might go to the city on the horizon; she'd wonder about its manufacturers, notice where the factories are, then paint the smokestacks against the sky. A farmer, on the other hand, might see the rich earth and paint the fields that he himself had plowed, sowed and harvested. These are two extreme cases, but each of us would find some aspect of the scene that appealed strongly to our sympathies.

### Picking and Choosing

Composition is simply picking and choosing from among all the elements of the scene. I like to think of it as the placement of the big masses of the picture; you "compose" when you decide where to put the horizon, trees, buildings, and other elements of the painting. There are no hard-and-fast rules about placing these elements. Some teachers are dogmatic and make their students equally rule-bound and inflexible. I prefer to think of painting as a series of decisions, the exercising of personal taste, judgment, and discretion. Taste, not rules, is what gives a work of art its dignity, elegance and "rightness."

Simplicity is one of the key elements of good composition. You have to learn to see the landscape in terms of a few large patterns. The eye naturally craves such ordering principles. If, for example, you were to cover a table with poker chips laid side by side, the eye would immediately begin to organize them into groups of four, five or six. The eye needs to simplify material to make sense of it.

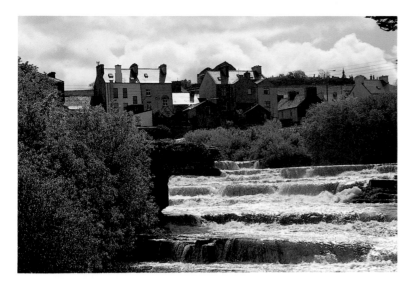

*Photo of scene*
In this photo of Ennistymon Falls, Ireland, we see the subject raw. Since cameras do not exercise judgment or selection, there is no composition, design or personal statement. It is up to me to put the "facts" into a dynamic design by sorting out only those elements that convey, in a carefully planned composition, what I found interesting.

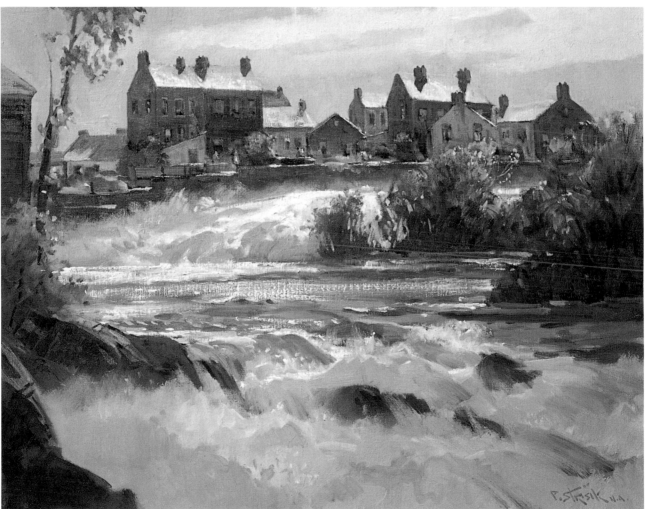

*Ennistymon Falls, Ireland,* 24″ × 30″
It is evident I took many liberties. The row of buildings has been redesigned and silhouetted against the sky. The bushes that obscure the more interesting water have been deleted and only those that contribute to good design remain. I made these changes (*picking and choosing*) to create a setting for the water with its brilliant top light, which was my primary interest. I simplified the details into a few patterns so the upper center of interest would dominate.

## COMPOSITIONAL PRINCIPLES

There are several important compositional principles to consider when selecting and placing the main elements of your picture.

### Weight

Probably one of the most fundamental principles of composition has to do with weight. As you distribute the masses in a picture, each has a definite weight in relation to its size and position on the canvas. If all the objects were on the left side of the painting, for example, it would obviously be out of balance; you'd feel as if the picture were about to tip over. The same thing would happen if you were to concentrate all your interest on the right.

It's therefore necessary to balance your picture—but not in an obvious fifty/fifty manner, distributing your weights equally on both sides of the canvas. It's an old, familiar idea in painting that you should avoid halves; that is, don't paint a picture that is half in shade and half in light, half warm and half cool in color, half sky and half land. Your picture will become too symmetrical—and monotonous. Of course, symmetry is useful in the decorative arts—in the making of

*Clamshell Cove,* 20″ × 30″
This subject matter is typical of the Maine coast. The strong silhouette of the pine tree on the left causes a dynamic distribution of masses, avoiding symmetrical, unexciting balance. To further boost the weight of this area, I have added a boathouse and boats. It would seem then that the painting would be heavy on the left, but on the right side, I have created a cloud shadow. And since an isolated spot carries much attention, I added a small bush on the right side also.

wallpaper, fabrics and jewelry. But in painting, we also want variety and interest as well as the decorative aspect.

I sometimes try to help students be less symmetrical by asking them to draw a border a few inches in from two adjacent sides of their canvases. If you have a tendency to center things, you'll do it in the resulting oblong, and when you work out into the rest of the canvas, your weight will automatically be slightly off balance.

## Center of Interest

All paintings should have a center of interest, and all other elements, while present, are secondary to the main interest. You can liken this to a play in which the main actors command the interest; other characters may be present, but demand no attention. If one of the minor actors suddenly scratches his head or creates some other distraction, it competes with the center of interest. So, also, an out of place note spoils the unity of a painting and, as a result, weakens the center of interest.

*Winter Chores,* 24″ × 30″
All paintings should have a center of interest. This composition illustrates this principle. It contains many pictorial elements, but the center of interest is clearly established by the figure, dog and dark of the building. The other parts of the painting do not take precedence over this all-important part.

### Cloud Shadows

Parts of a painting may be subordinated by the use of cloud shadows. One fellow artist called them "the painter's friend." They change quickly, so it is necessary to determine your light and shadow pattern early and stick to it. This is one way to enhance the parts of interest.

## DESIGN

Once you've determined your placement of the main elements of a scene, you need to think about design, which is the further refinement of compositional shapes into more considered, sophisticated forms. To some extent, this requires a stylization of the rhythms, shapes and angles of your subject—aspects that are often only subtly suggested by nature. In design, then, there's a hint of caricature. You sense the character of what you see, exaggerate it, and thus express it better on canvas.

*Lifting Clouds,* 16″ × 20″

This is primarily a sky painting, since two-thirds of the painting is taken up by sky. To make the sky interesting, I painted a moving front, which creates varied and interesting shapes. Since there were clouds, I created cloud shadows on the right side of the land, part of the boathouse, and on the distant land at left.

*Morning Surf,*
16″ × 24″
This painting depicts silvery morning light. I avoided all detail, making all of the foam and water very close in value, with the rocks a contrasting dark value to reinforce the light areas.

Design is what saves our paintings from being trite, banal, purely "naturalistic" pictures. It adds intellectual sophistication to our work. When you look at the work of great muralists and illustrators — Frank Brangwyn, for example, or N.C. Wyeth — you immediately see how they were able to fit the facts of nature into a coherent whole. Any religious picture from the Renaissance would show the same sense of design. The robes of a prophet or the Madonna are never photographically rendered; the painter picks just those folds that relate to the body, lead the eye to a focal point, or otherwise serve some pictorial function. You may not consciously realize how the painter is using the folds, but the care and consideration add strength and a sense of "richness" to the composition.

## Water

More than almost any other subject, water must be painted in terms of rhythm. It's impossible to capture each rivulet and splash of foam. Rather than drawing the anatomy of the water, you should squint your eyes and look for areas of contrasting value. Squinting kills the unnecessary detail.

Students usually make foam too much like balls of cotton. If there's any breeze at all, the foam will be blown in one direction or another. In the painting above, for example, the wind comes from the right and compresses the foam on the windward side of the wave, where you see the suggestion of a sharp edge. On the leeward side of the wave, however, the foam blows away, resulting in a soft edge. This contrast of hard and soft edges gives naturalness, weight, design and beauty to the water.

## SHAPES

The shape of each subject—trees, rocks, water—expresses the characteristics of that subject. But these shapes should also be pleasing in and of themselves—pleasing, that is, in an abstract way. Unfortunately, students are usually so busy trying to make things "look like" what they are, by describing textures and colors, that they hardly ever consider shapes. When you work piece by piece, you end up with a collection of unrelated parts. How often have you labored over a house in one of your paintings and finally sighed, "Thank goodness that's done; now I can do the trees"? That's the wrong way to proceed. In a good picture, all the pieces fit like the parts of a well-designed machine; if you remove one part, the whole machine breaks down.

Not only must each shape be effective in itself, it must also have a fine relationship to each of the other shapes in the painting. And you must also give careful consideration to the spaces between your principal objects. You can paint a house and a tree, but if you ignore the design of the sky showing between them—what is called the "negative" shape—it may have an ugly repetitious contour and thus ruin your picture.

Remember that the canvas has an independent existence. The landscape is one thing, the picture another. You have to learn to use shapes that work with the picture. The student's view of the painting process is completely different from that of the seasoned professional. This has nothing to do with technical facility, but rather with a fundamentally different way of looking at the subject. This is to be expected; the most intelligent person, given a paint box for the first time, wouldn't know how to see as an artist. Thinking naturalistically, the average student looks at a tree and sees the bark, branches and individual leaves. The professional, on the other hand, sees a particular mass and shape against the sky. The professional sees the design possibilities, while the student sees only the parts that make up the whole. As a result, most student pictures are full of details that never quite fit together. The student uses the eyes, but the professional uses judgment.

### A Warning

Although it's necessary to look for the characteristic aspects of your subject, don't overdo it! Your pictures then begin to look like cartoons or posters. Design isn't an end in itself; it should be used to strengthen the theme of your picture. Because of an overriding interest in design during the 1920s and 1930s, many of the landscape paintings from that period have a mannered, overly decorative look. Today these pictures look oddly false, like miniature stage sets. An artist's excessive concern with design keeps viewers from relating to a familiar world—a world in which they can walk and breathe. Design is important, but it shouldn't threaten the viewers' emotional responses to your painting.

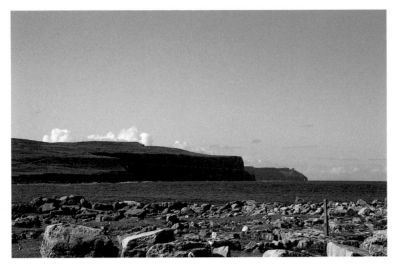

*Photo of scene*
While waiting for the boat to the Aran Island, I made a quick 8″ × 10″ oil study of this beautiful Irish coastline.

*Galway Hookers, Ireland,* 15″ × 20″
Back home in my studio some weeks later, I reviewed my sketches and information gathered during my stay. I wanted to use this coastline, but a composition and setting had to be developed. Using another study of traditional Irish fishing boats called "Hookers," I formulated this composition with an effective use of shapes.

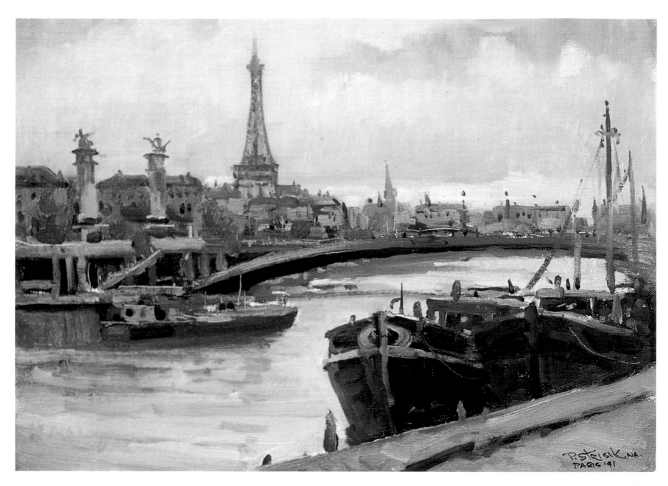

*Pont Alexandre III, Paris,* 10″ × 14″
This is a field sketch painted on an overcast day along the Seine. The light, sky and water offered good opportunity for contrast, using the dark barges in the foreground to reinforce this. Atmosphere caused the distant buildings and detail to be painted with subtle grays.

## ORIGINALITY

Some people think being "original" means hitting people over the head with a bucket of paint. Yet "conventional" paintings can still be very inventive and creative. Each of the Rocky Mountain painters—Moran, Bierstadt, Church and the rest—gave a highly personal turn to what, at a superficial glance, looks like extremely realistic, academic work. In our own day, Andrew Wyeth's viewpoint transfigures what at first appear to be careful transcriptions of nature. The fact is that if you took any two great painters—Velasquez and Rembrandt, for example—and asked them to paint a portrait of the same person, they'd both get a likeness. But you'd also know who painted which picture. Powerful personalities put their mark on whatever they do. That's why I keep repeating that simply describing the facts of a scene has nothing to do with the painter's true craft. Painting the truth doesn't mean making a literal picture of something; it means creating a faithful representation of an emotional experience.

On some days, we all go through the motions of painting. We squeeze out paint, but forget that it's not enough just to cover a canvas. Too many paintings are excuses for covering canvas! If you're not excited by the subject, the viewer won't be either.

At the same time, it takes tremendous strength of character both to stay faithful to good painting and to present a part of yourself in every canvas. The pressures of day-to-day life affect our work, and every painter has sold pictures she'd love to get back and burn. My teacher Dumond used to say that "if you paint through the eyes of the buyer, you'll grow to hate your profession and, what's worse, yourself!" Nor, I should add, am I altogether pure and unsullied. In fact, when I lecture, I'm really lecturing myself; I'm reminding myself what painting is all about. We all need such reminders if, when the time comes to lay down our brushes for the last time, we are to have done enough sincere work to justify our craft.

To many students, this kind of talk may seem abstract and high-flown, but it's really very practical. Unfortunately, most people can't *accept* in painting what they *expect* in the other arts. Consider literature: Not being a writer, I might need ten pages to describe Rockport Harbor. I'd list all the details of the scene and hope that these pieces would give the reader a sense of the place. Tolstoy, on the other hand, could do the same thing in a paragraph. He would describe only the characteristic aspects of the scene. We don't expect him to tell us everything; if he did, we'd find his writing tiresome.

A good writer uses verbal symbols to create a mood. As a painter, you can actually show the viewer a tree or a mountain, but if you are not selective about which details to leave out or emphasize, the writer's description will be a more effective statement because it's more personal. When you paint things exactly as they are, you don't show people anything they couldn't see for themselves; you're telling them what they already know. The viewers, however, don't want to sort out the truth all by themselves—they want you to help them. As Charles Hawthorne said years ago, the painter "must show people more—more than they already see, and he must show them with so much sympathy and understanding that they will recognize it as if they themselves had seen the beauty and the glory."

# COMPOSITION PORTFOLIO

Now that you're familiar with basic design and compositional concepts, let's visit some painting sites and see these concepts at work. I often take photographs of a subject after I've finished painting outdoors; so in many of the examples that follow, I can show you what both the spot *and* the painting look like. Since I photographed each of the sites after I'd spent the day painting and the sun had changed position as I worked, you'll notice that the light in the photo doesn't always match that of the painting. When I look through these photos, I am sometimes surprised by the appearance of the actual site. Since the painting contains so much of my emotional response to nature, it *becomes* the place for me, and I forget how the spot "really" appears.

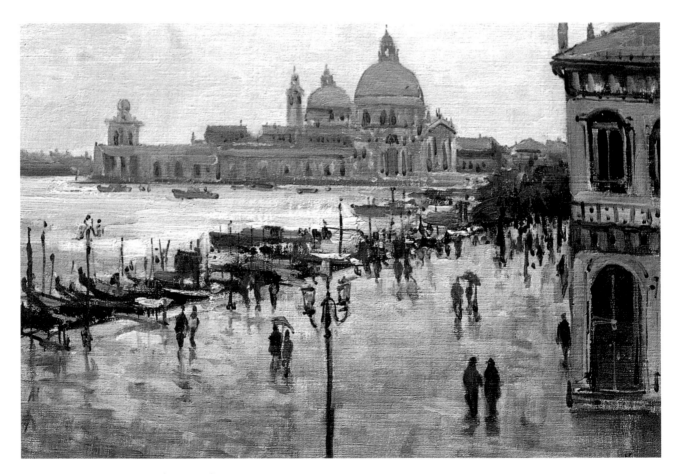

*Silvery Light, Venice,* 10″ × 14″
It was raining this day, but I found a vantage point in the upper balcony of the Ducal palace where I could do this small sketch in dry comfort. I kept the foreground relatively simple so the eye could gravitate to the upper, and busier, portion. The line of the waterfront helps this. It would be an uninteresting painting without the beautiful Salute church in the distance, treated in soft gray tones. Warm sky tones promise clearing weather.

*Ballyvaughn, Ireland*, 20″ × 30″
I created shadows from nonexistent trees and buildings in the same way I use cloud shadows; that is, I suppress parts of the painting to allow the more important interest to dominate.

***Autumn Patterns,*** 16" × 20"
A hayfield in the foreground was included in the first study. Later in the studio, I realized it was the farm buildings set against the trees in the rich flat light that attracted me to the subject. I then changed the bright yellow hayfield into a grassy field broken by a few rocks with a road to lead the viewer into the painting. A subtle hint of a violet mountain above the trees set off the farm and completed the composition.

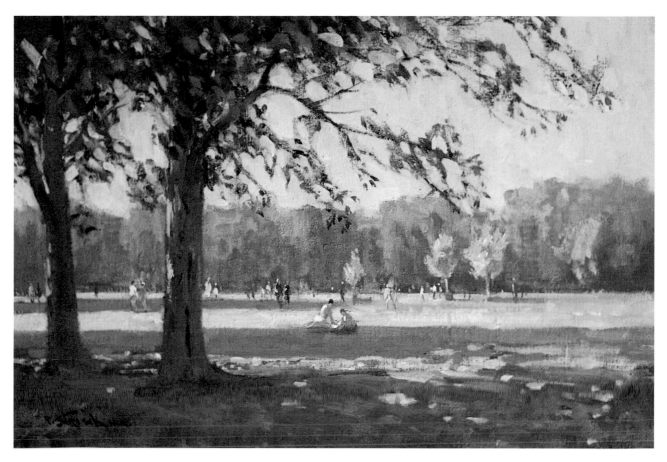

*Hyde Park, London,* 16″ × 24″

This beautiful subject attracted me immediately because of the long horizontal lines counterpointed by the dark vertical trees and foreground shadow. The weight is on the left, but several main figures give the eye a focal point. Other smaller figures are suggested throughout the park. Atmospheric haze makes a very light sky and soft background trees.

*The Shell Collectors,* 16″ × 24″

This was one of those beautiful crisp, clear autumn days. The tide was low, enabling me to create rivulets of water to zigzag toward the figures, the center of interest. Since the air is dry and clear, saturated colors are used, which give a rich effect.

*Indian Creek,* 12" × 16"
This depicts an autumn day in Taos, New Mexico. The center of interest and focus is clearly stated
with the red tree against the very light bridge. This is one of the times I used a palette knife.

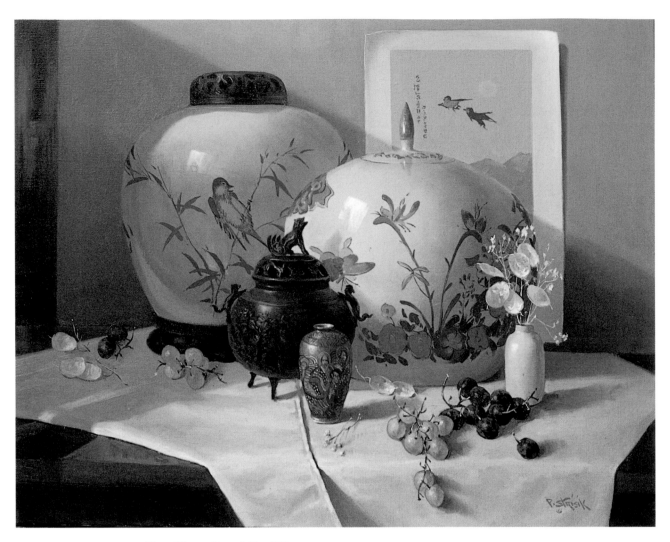

*Two Ginger Jars,* 24″ × 30″

This still life shows that the language and principles of paint are the same whatever the subject may be. This collection of oriental objects is set up to lead your eye through the painting. The focal point is clearly defined by the dark bronze incense burner against the very white jar. To suppress competition with the other jar, I have put it into a half light and further created a shadow on its left side to merge with the cast shadow coming from outside the setup.

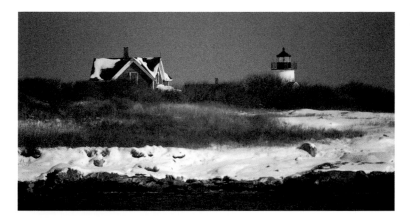

*Photo of scene*
Here you see a photo of the subject as it appeared on a winter day. It appealed to me, but the composition needed work.

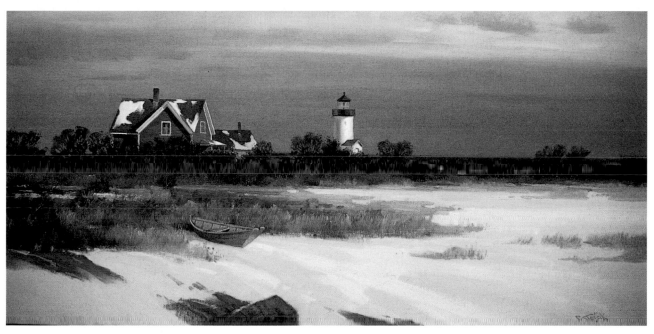

*Straitsmouth Winter,* 20″ × 40″
I chose a long format of horizontals so the verticals of house and lighthouse would be strengthened by the contrast. I painted less brushwood so the ocean could be included. I did not include the foreground water; I preferred the eye to enter the painting with no hindrance. The dory, rocks, and shadows on the snow all lead into the painting. I used a rich overcast sky to enhance the whites.

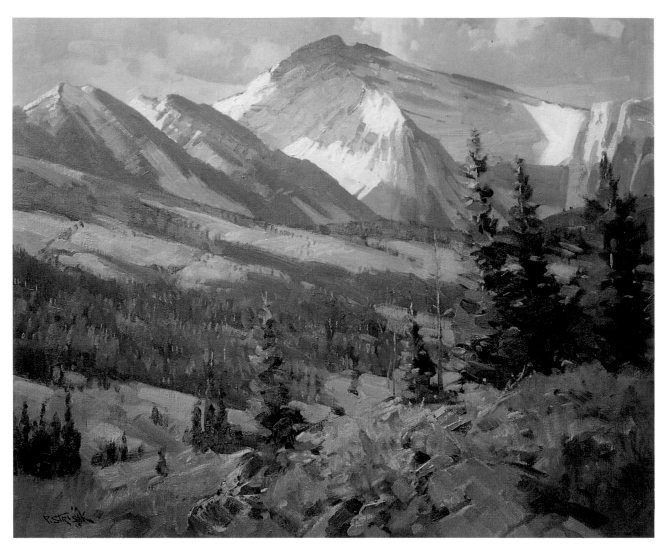

*Mountain Jewels,* 24" × 30"
Our western mountains are wonderful to paint. The forms are all massive, and there is a heroic quality about them that calls for broad treatment. I used a series of angles in counterpoint to lead up to the main interest and strongest effect of sunlight. The strong verticals of the trees bring the foreground forward, and give a sense of atmosphere to the distance.

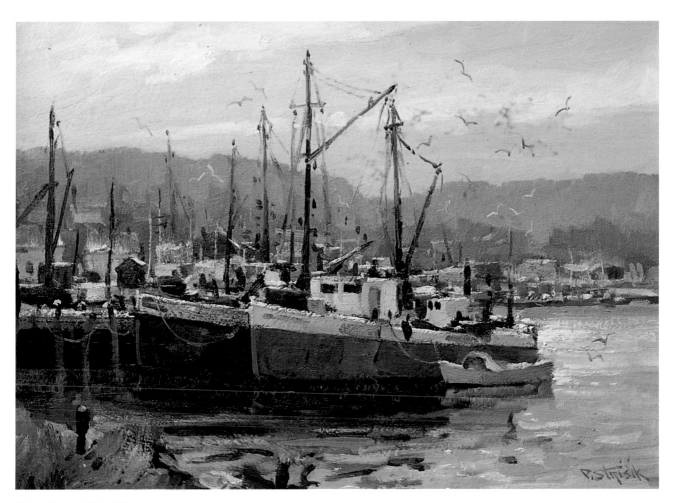

*Home Port,* 12″ × 16″
This is a typical subject around the Gloucester waterfront. On this morning it was a bright gray day creating a strong top light on all the flat planes. I ignored the very busy background as too much competition to the main interest. Instead, I pushed it back by a simple light, cool tone. The boats and foreground darks are painted with rich color.

# PORTFOLIO OF FIELD SKETCHES

These field sketches are painted with the portable outfit shown in the previous chapter, which I use when I travel by air. Time is usually limited, so the field sketch is my solution. I keep these paintings as my notes until I can do larger, more ambitious compositions in the studio.

*Alcantara Bridge, Toledo, Spain,*
*10″ × 14″*
This bridge was built by the Romans. The sunlit stone contrasted beautifully with the cool colors of the water and sky.

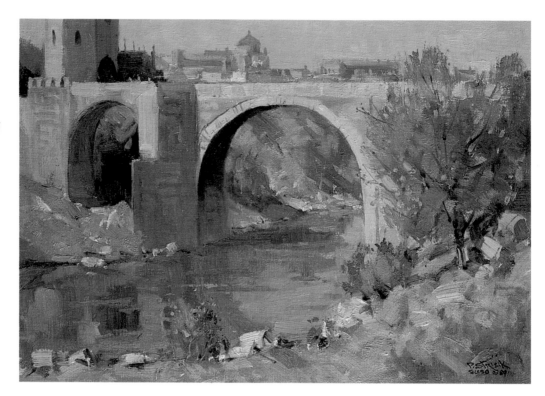

*Toledo, Spain,*
*10″ × 14″*
A bright, clear sunny morning brought sparkling contrast to this subject. I concentrated my efforts on the church and buildings, leaving the foreground as simple as possible.

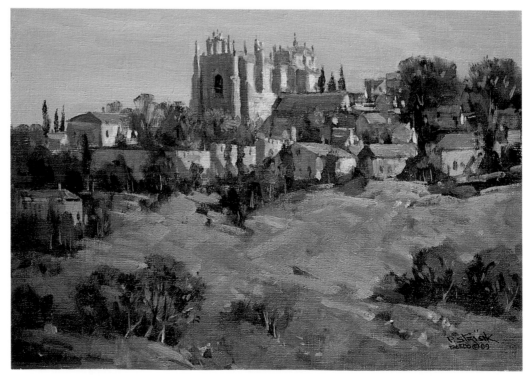

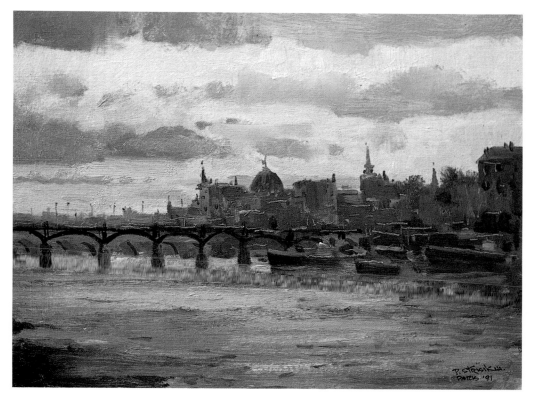

*Clearing Skies, Paris,*
*10″ × 14″*
The mood was irresistible this morning along the Seine. The clouds were lifting and subject matter held together in a beautiful variety of grays with subtle top light.

*Evening Light,*
*Venice, 10″ × 14″*
I painted while looking almost directly into the sun and tried to capture the haze and sparkle of the evening light. I added the dock on the right so I could make use of rich darks.

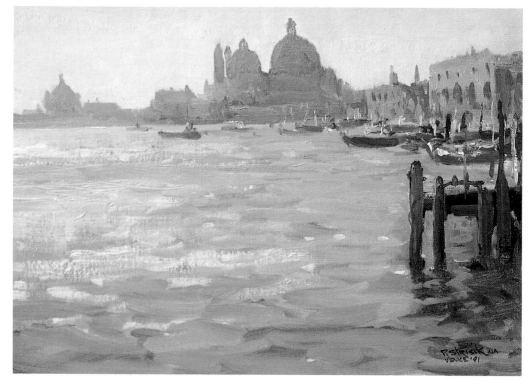

*Barge on the Yonne, France,* 10" × 14"
I found these river barges interesting, as they were so different in shape from boats I had painted for years in New England. The day was overcast, but contrast was provided by the sky and water.

*Breaking Light,* 10" × 14"
This kind of beautiful effect is so very fleeting; I had to paint the essentials as quickly as possible. The dark strip of land and trees furnished the perfect darks to reinforce the effect of light.

*Hobb's Farm,*
10″ × 14″
There was no mistake as to where the interest was here. The shadowed barn against the sunlit house created a lively effect. I painted a shadow on the foreground to keep focus on the light.

*Taos Mountains,*
10″ × 14″
This was a beautiful subject in the flat afternoon sunlight. I welcomed the dry grass and yellow house to complement the beautiful blue and violet of the mountains.

# LIGHT AND COLOR

If you're going to paint light, you have to understand how it works. I believe in cause and effect; if you understand the reason for a visual effect, you'll be better able to paint it. We should be "researchers" rather than "practitioners"—that is, we should discover the whys and wherefores of things, and not simply practice formulas given to us by our teachers. Just as a music teacher teaches *music*—not how to play the work of a particular composer—a painting teacher teaches *painting*. You must learn to analyze what you see, so you can eventually arrive at your own answers.

It would be easy for me to give you formulas. I could show you "how to paint a rock." But to do the job properly, I'd have to discuss nearby rocks, distant rocks, sharp rocks, smooth rocks, rocks on sunny days, rocks on gray days, rocks in light, rocks in shadow, green rocks, brown rocks, etc. Your notes would fill a filing cabinet as big as a house. And you still wouldn't have all the "answers."

You have to learn to study nature as carefully as your artistic predecessors did. Carl Rungius, a famous wildlife painter, hunted animals, dissected them, and painted and drew their carcasses until they rotted. He also studied the habitats of his subjects and left, at his death, thousands of drawings and small oil sketches. Like most good painters, he analyzed nature so intently that he had no need for formulas. Likewise, when you paint the effects of light, you should continually observe and study nature; don't allow yourself to fall into clichés and easy formulas.

*Vermont Winter,* 16″ × 20″

## VALUES

To study light, it's a good idea to begin by looking at one of the most obvious characteristics we observe in nature: values, or the relative lightness or darkness of an object.

### Lights and Darks

Painting students tend to be fascinated by color, but for the moment, I want you to forget about color. You may be surprised to find that it isn't as important an element in art as most people think. There were few truly great colorists among the Old Masters, who instead relied mostly on values to describe the effects of light. In fact, color isn't essential at all. When you look at a black-and-white TV show, you understand what you see; you know what's close and what's in the distance, what's rough and what's smooth, what's square and what's round. Sometimes, color can even be a distraction. For example, the black-and-white movies made in Italy after World War II had a stark dignity that perfectly matched their sober subject matter. Had they been filmed in color, I doubt they would have been so effective.

For the moment, consider how a scene looks when you take a black-and-white photograph of it. This isn't easy, for most people rarely think in terms of light-

*The Blue Door, 20″ × 30″*
This is a typical late winter afternoon with an obscured sun in a bright sky. All else is in halftone by comparison. The snow is kept as light as possible, but cool in tone. The dark colors are rich, the accents strong, and all is relieved by a stark simple foreground.

and-dark relationships. After you see a luminous painting in a museum, you tend to remember only the beautiful effect of light; you forget the darks that set off those brilliant lights. Similarly, if you look out a window, your eyes are immediately attracted to the lightest areas; you ignore the shadows.

## Value Relationships

A good painter seldom worries about isolated objects, concentrating instead on the relationships among the few simple masses that create an effect. Rich darks are necessary to reinforce lights, but the student painting outdoors is usually tempted to isolate these darks, staring into them and thus misinterpreting their relationship to the light. If I look into the dark of an open barn door, for example, my pupils dilate to adjust to the weak illumination, and more light enters my eyes. Inside the barn I can see a hayloft, supporting posts, a wheelbarrow and other details. But if I look at the sunlit side of the barn, my iris closes down, accommodating itself to the brilliant glare. In this context, the open door now appears much darker. To suggest the full impact of a scene, you have to judge the shadows while looking at the lights.

*Road to Bakersfield,* 16″ × 24″
In this painting, the late afternoon light is breaking through at the horizon, and even the darker clouds are kept fairly light in order to preserve the character of such a day where the earth holds together as a mass against the sky. Had I peered into the dark hill in the background or the foreground greens, I would have seen many different values in those areas. But it's important to keep your eye on the whole effect and keep the colors in each area within one value range.

## COLOR HARMONY

Years ago, painters strove for a harmonious "Rembrandt effect" by running brown glazes over all their pictures. They tried to manufacture the harmony that dust and varnish had given to the work of the Old Masters. The outdoor painter doesn't need such tricks, for nature has its own special harmony, created by the unifying influences of light and atmosphere.

Unfortunately, many students can't see this unity; they're too worried about local color. If the grass is green, they paint it "green"—sometimes right out of the tube. They are likely to paint the dark roof of a sunlit house black, even when, compared with a shadow thrown on it by a chimney or nearby tree, the roof appears relatively light and warm. Similarly, a macadam road is always dark to the student because he knows it's made of black material. But if you are driving into the sun, the road can stretch like a ribbon of silver before you and a rich line of dull purple or blue behind you. Because of the effects of light, local color is of little importance.

Preconceived ideas about the appearance of things are one of the main enemies

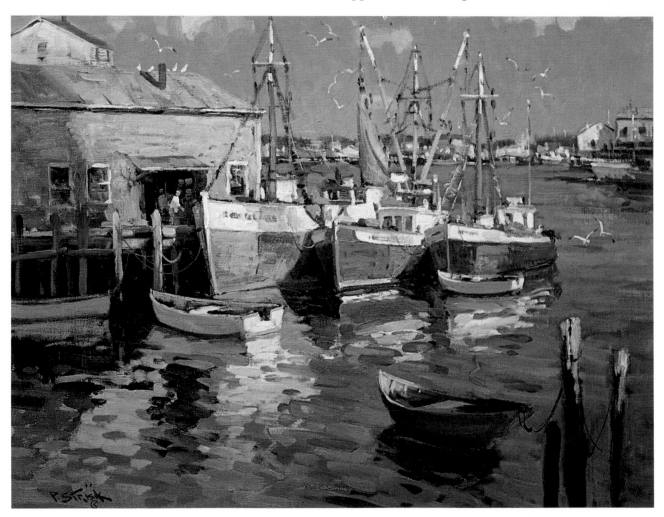

*Gloucester Wharf,* 20″ × 24″
This is an example of flat light that happens when the sun is behind the viewer. The colors are purer and saturated. There is a clear warm afternoon light, and what shadows do exist are very dark and rich. I have also created shadows on the building at left and in the foreground to add interest and enhance the center of interest.

of the painter. Dumond said that we drag such ideas after us like tin cans on a string; sometimes it seems to take dynamite to blast one of them loose. An object itself isn't so important; what counts is what light does to it. Thus, if we were to paint the same scene on gray and sunny days, we shouldn't be able to cut the pictures into pieces and interchange the parts. Each set of pieces should have its own unifying tonality.

## The Color of Light

When I paint, I want the viewer to feel the kind of day it is and the exact nature of the weather. Sometimes I begin working simply to record my joy at the day's clear, bright light.

The entire scene must convey the impression of luminosity to the viewer. In prismatic painting—that is, the use of nature's entire spectrum in our color rendering—yellow is the sign of energy, the gold of the day. Violet, at the other end of the spectrum, is the lack of energy, the purple of the night. Think of a bar of iron as it comes from the furnace. At its hottest, it's full of energy and whitish yellow with light. As it loses energy, it becomes a deeper yellow, then orange, then red and, finally, violet.

Sunlight is identified with the energy of yellow and other warm colors; shadow, with violet and other cool colors. Of course, light from the sun isn't pure yellow,

*Morgan's World,* 16″ × 24″
Here is an all-out effort to portray the glare of the sun on wet surfaces. It is a good example of how graduating the light can achieve brilliance. In this case I chose rich darks for the vertical planes, with a minimum of reflected light, and a light greenish sky filled with light.

nor is it always of the same strength. Its color and intensity are affected by the sun's position in the sky and by the layers of air, dirt, and other suspended matter in the atmosphere through which the light passes before reaching us. At noon on a clear day, for example, the sun is a yellow-white. It shines through a relatively thin layer of atmosphere. As the sun moves lower in the sky, it has to work its way through a thicker, transverse section of the atmosphere. This layer filters out more of the sun's energy. As a result, light from the evening sun looks orange rather than yellow; and as the sun moves even lower, it becomes a cherry red. At each stage, it bathes the landscape with its color.

These are obvious examples of the color of light. Yet the color changes all through the day. If we could "freeze" bits of white paper left outdoors at different times of the day—morning, noon, afternoon, twilight, night, on bright and overcast days—not one of the frozen pieces would look pure white. One might be reddish, another a dull blue, one black, another slightly green, and so forth, depending on the time of day and the conditions. This gives each scene in nature its harmony of color relative to light and atmosphere.

*Ponte Victor Emanuele, II, Rome,* 24" × 20"
Since much of the subject was in shadow, I added interest by using reflected light from both the sky and sunlit portions of the bridge. The darks under the bridge are invaluable for boosting luminosity in the shadow portions of the bridge. I only suggest carving detail in the broadest way. The sky appears dark in contrast to the white sculptures. It graduates from a greenish blue to a more gray-violet tone at the top.

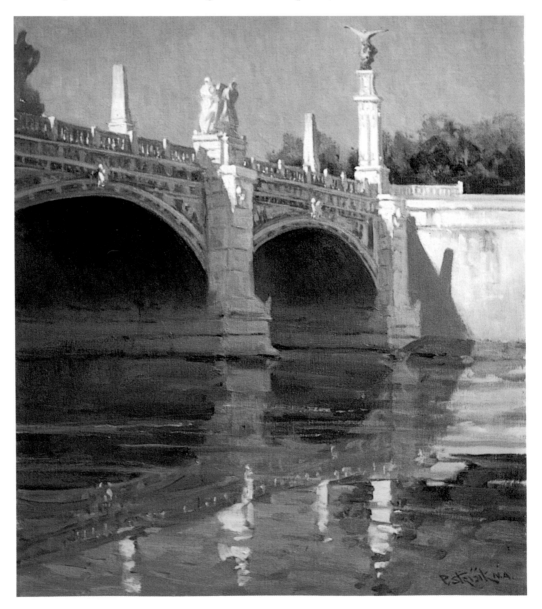

## The Color of Shadow

Shadows confuse students because they think of them as being different colors. What color, they ask, is the shadow side of a green tree or a red apple? To understand shadows, don't worry about their different colors. Instead, think of all the shadows in your picture as related by the fact that they're devitalized forms of energy. They all share a hint of our most devitalized color, violet. As a simple exercise, try laying in all the shadows in your picture with the same red-violet color (mixed from ultramarine blue and cadmium red medium). Put down the darks with a posterlike simplicity, thinking more about value than color. If you do a tree, for example, paint its shadowed side gray-violet. You can add green later; the violet will mix with and devitalize the green.

As you understand shadows better, you can temper this simple idea with knowledge and taste. For the time being, learn to think of light and shadow in terms of

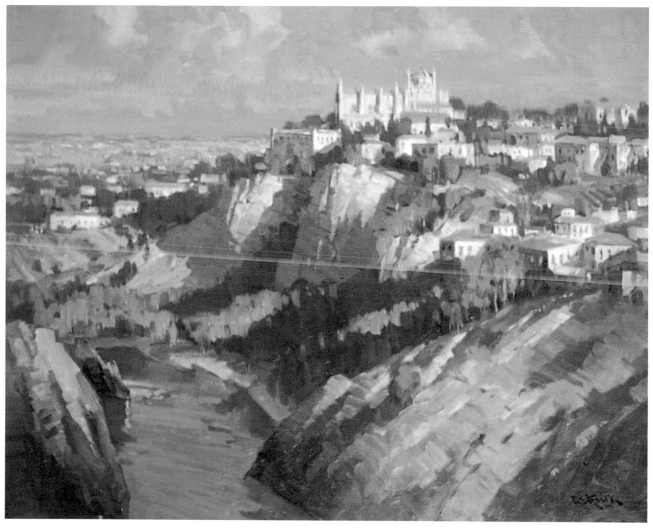

*Toledo, Spain,* 24" × 30"
Another view of Toledo, this time including the Tajo river below. I have placed all of the interest in the area around the dominating cathedral. I used the shadows from the cliffs to suppress interest, giving more force to the sunlight portions. When doing such an expansive subject, choose or add only those buildings, trees, etc., which convey the effect in a dynamic composition.

energy—energy expressed in terms of values. Seen this way, lights are light, darks are dark, and the color shifts within them are relatively unimportant. If you were to make a page of color samples from the highlights in one of my pictures, you'd see that they were all similar in value and only slightly different in color, like the face powder charts you see in department stores. The same would be true of the shadows. The purer colors would be seen mostly in the areas of middle values, where neither sun nor shadow exerts an overriding influence on color.

### Atmospheric Perspective

As we've seen, the energy of the light is affected by the volume of air that surrounds us and covers distances like a veil. Fog is an exaggerated example of this phenomenon; the material in the air—moisture in this case—becomes so thick that it's visible. Yet even on a sunny day, the accumulation of atmosphere pervades nature with a subtle, elusive silvery gray quality.

The danger of too much studio work is that you lose this feeling of air in your paintings. You start thinking in terms of pigment and neglect the atmosphere that ties nature together—the unity of tone that was so important to an older generation of landscape painters.

Because of the effects of atmosphere, colors tend to get grayer and lighter in

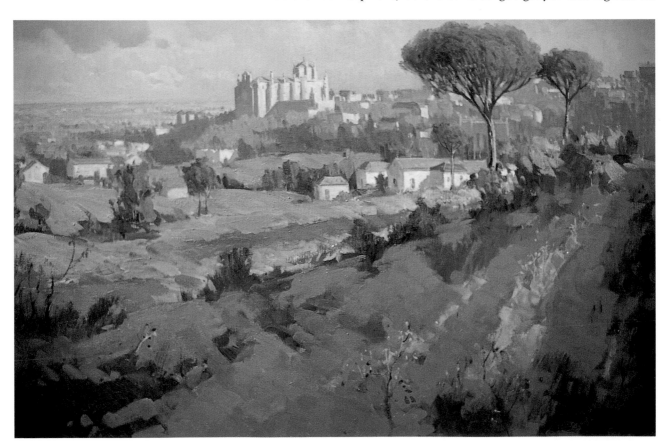

*Morning Light, Toledo, Spain,* 24" × 36"
In this early morning, the shadows were long, and a brilliant haze enveloped the scene. I welcomed the long foreground shadow to add a rich luminous quality to the lights. The haze made the atmosphere itself hold the light, causing distant shadows to be lighter and cooler as they recede. The progression of accents from the foreground into the distance adds much to reinforce the light.

value as they recede. You can shout in the foreground, but have to whisper in the distance. In the far distance, colors also get cooler, with the exception of white; it gets warmer as it moves away.

This graying and cooling effect occurs over both long and short distances. To see this, take two small pieces of either white or colored paper, and put one piece on a table a few feet from you. Hold the other in your hand, a foot from your face. Close one eye and overlap the cards. You'll see that the distant card is a hair grayer, though only a few feet away. Similarly, the next time you're outdoors, pick up a green leaf or blade of grass and compare it to the distant trees. You'll be astonished at the difference in color.

The atmosphere also affects values. A distant black roof is lighter than one near you, even though both may be shingled with the same material. A storm cloud, while it looks quite black in the sky, isn't as dark as you think. Compare it to your stick of charcoal. The effect is noticeable even in a still life: A white tablecloth grays a bit as it gets farther away from you. Imagine what would happen if you were painting outdoors and a car were to drive between you and your subject. A cloud of dust would scintillate in the air, obscuring objects in the distance. There's a veil of dust in the air all the time, though it's not always so dramatically visible. Remember that volume of atmosphere when you paint, and you won't make the common student mistake of overstating your distant colors and values.

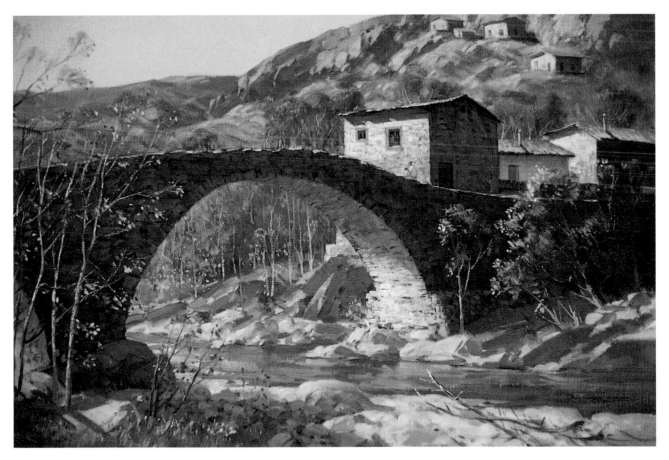

*The Bridge to Malbos, France, 20″ × 30″*
This is a beautiful medieval stone bridge in southern France. The day was bright, with just enough atmosphere to add recession into the distance. Since I am looking somewhat into the light, the shadow side of the bridge acts as a wonderful contrast to the lights.

## LUMINOSITY

Having discussed values, the color of light and shadow, and the effect of atmosphere, now let's take a look at those aspects of light that give a picture a feeling of luminosity.

The first thing to remember is that you're working with inert pigments, not sun and air. A sunset has overwhelming color and luminosity, but our pigments don't have that kind of energy range. Compared to the range of light in nature, the luminosity of pigments is as one inch is to a thousand miles.

The painter learns to make compromises, realizing that in a painting, luminosity and brightness of color are two different things. Many students think they can emphasize the brilliance of a sky by putting a jet black tree in front of it. The contrast certainly makes the sky look bright, but such lightness is an aspect of paint. You don't want brightness; you want luminosity. And that can only be achieved by understanding some essential characteristics of light: diffraction, reflection, gradation and transparency.

### Diffraction

Light is full of energy, whether it comes directly from the sun or indirectly by bouncing off the features of the landscape. The tremendous energy of the sun's direct light influences everything in its path. For example, if you were to hold a quarter-inch dowel vertically in front of a red, yellow and green traffic light, you'd see the dowel become slightly red as it passed in front of the red light. In front of the green light, it would take on a greenish tinge, and in front of the yellow light, it would look a little yellow. This happens because the light rays creep around the edges of the wood, an effect known as diffraction.

The same thing constantly happens in nature. The radiant blue of the sky, for example, acts much like the traffic light. John F. Carlson, the respected painter-teacher, noted that the thinner a white church steeple becomes, the more it's influenced by the blue sky behind it. In theory, it's therefore cooler at its apex than at its wider base. Branches against a blue sky are also influenced by the energy of the sky. The smaller the branches, the cooler they appear. These effects aren't always visible, but the painter can use these principles to create more convincing work.

Direct sunlight has an even stronger influence. In a harbor, for example, the rigging of a ship seems to disappear when the mast passes in front of the sun, making it light in value and warm in color. On an overcast day, the energy of the sun eats away at nearby clouds. As a result, the darkest clouds are usually those farthest from the light.

We can see a similar effect when we look at a window on the sunlit side of a white house. In this case, we're not dealing with light directly from the sun. But the house reflects so much energy that it becomes, for all practical purposes, a source of light in itself. J.M.W. Turner used this idea with brilliant effect in his Venetian paintings. When he painted a white palazzo bathed in sunlight, the windows nearly disappeared. The sunlit white house radiates light away from its outside edges, too; thus the line between house and background would be fuzzy in places, rather than harsh and sharp.

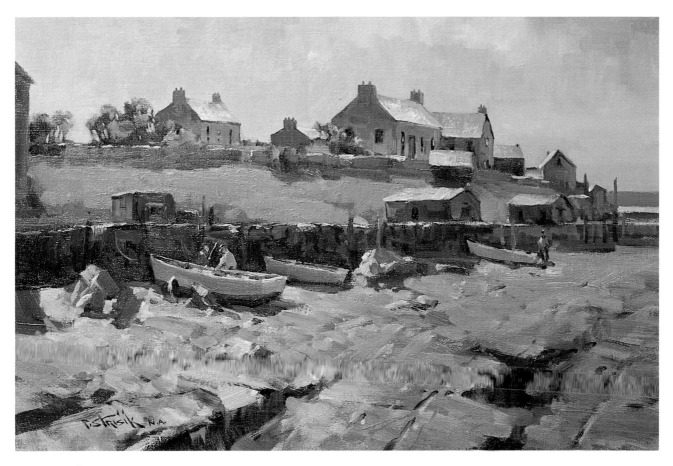

*Aran Island, Ireland,* 16" × 24"

This painting portrays the effect of top light. In such cases, all of the flat planes reflect the light, and all verticals are in shadow. The vertical planes appeared almost black. However, to paint them that way might make the lights seem *lighter* but not more *luminous*, which is what we are after in a painting. Therefore, I filled them with reflected light, warmer at the bottom, graduating to cooler above, and a bit darker. The rock wall served my purpose, being dark, but even here I introduced some sky influence. The sky is kept very light to enhance the silhouette.

Returning to our original problem: the dark tree in front of the light sky. The tree wouldn't be jet black all over; on the contrary, the light would eat away at it. As the branches got smaller, they would not only get lighter in value but also slightly warmer in color. As soon as the trunks and branches move in front of the brilliant distance, they become lighter in value, adding luminosity.

### Reflected Light

As we've seen, light reaches us in two ways. It comes directly at us, or it's reflected off objects. The amount of reflection depends on the nature of the material. A harbor in the Bahamas is light because the sun goes through the ocean; bounces off the white, sandy bottom; and illuminates the clear water. The boats seem to float in air. In New England, on the other hand, the light also goes easily through the water, but it's absorbed by the dark bottom and by suspended matter in the ocean itself. Similarly, a golf course is all grass, but the well-mowed putting green reflects a lot of light, the thicker fairway reflects less, and the rough actually absorbs some light. When you look across the course, your eye sees the different values, and you immediately know what is smooth, semismooth and rough.

As a student, it took me a while to understand this principle. I once painted a field in flat light; the sun was directly behind me. I struggled to get the feeling of

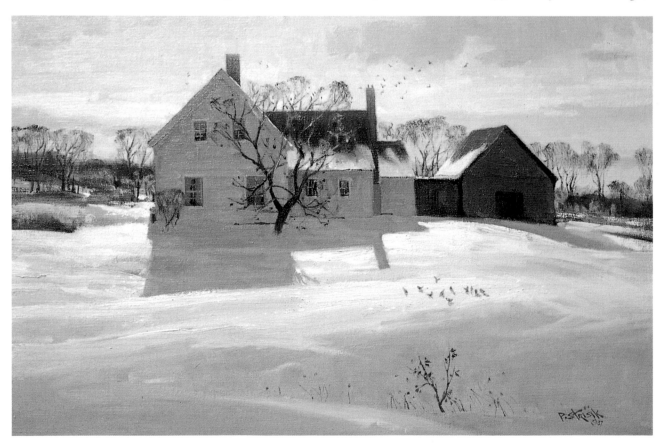

*Frosty Morning,* 16" × 24"
In this painting, I wanted to capture a brilliant morning. Because I was looking into the light, the shadows were filled with reflected light. The sky, being the source of energy, contains a hint of yellow. It was important that the house, even though white, was kept as luminous as possible while still remaining a silhouette.

a sunlit meadow, but the more yellow and white I used, the less convincing my effect was. The teacher listened sympathetically to my problem and told me to take a handkerchief and lay it down far out on the field. When I got back to my easel, he noted that the handkerchief appeared as an obvious white spot in the meadow. But when he put a dab of white paint on my painted meadow, it barely registered. In trying to make the meadow bright, I'd made it too light in value. I'd forgotten that such a surface absorbs much of the light from the sun, which lowers its value.

*Dogwood,* 30″ × 30″
I don't often paint flowers, but could not resist these beautiful dogwood blossoms. I painted, with particular care, the quality of light striking them from the left and the very luminous quality of the shadows on them, adding a hint of warm reflected light. All of this subject matter is against a rich, warm, dark background.

## Gradation

Reflected light varies in intensity. This variation takes the form of gradation. When sunlight hits a very reflective surface, such as metal, it's reflected almost perfectly, and the result is a brilliant highlight. But only a small part of the material reflects the full force of the light. Other areas catch the light at different angles. As a result, you can never just create a highlight with a spot of white paint. It will always look like white paint. A real highlight, on the other hand, is bordered by areas that become progressively less bright; it's shaped like a teardrop or like a comet with a tail at both sides. The gradation toward the light is what makes the highlight so effective. In the middle of a quiet musical passage, a cymbal crash would be noise. But as the final note in a crescendo, it's exciting and stirring.

This basic principle—seen in miniature in the case of a highlight—applies to the landscape as a whole. Imagine a field covered with thousands of pocket mirrors. Given the lay of the land, a few of the mirrors would be positioned in such

*Along the Maine Coast,* 20″ × 30″
Note how the areas of brilliant light eat away at anything that approaches them, such as tree branches or even the horizon. Also, see how the light on the roofs is intensified by gradating the light. We are looking directly at the light source, so the top lights are very strong.

a way that they'd reflect sunlight directly into your eyes. Those spots would have a glare, others would reflect sky, etc. As the mirrors moved up and down the adjacent, irregular planes of the landscape, they'd naturally reflect less light. Occasionally, a bump in the terrain might angle a mirror so that it caught a glare from the sun, but that would occur only here and there.

Gradation helps give a landscape a feeling of luminosity. If you ignore it, you merely label things: "This is light; this is shadow." As labels, simple light and dark masses are no more convincing than the jet black tree against a bright sky; they make you think of paint—not light. Since gradation is so important, I introduce it into a picture even if I don't actually see it. Corrugated metal farm roofs, for example, often reflect the light as a single brilliant glare; you can't see a hint of gradation. But you won't express the brilliance of such a roof by painting the entire mass with white and yellow pigment. The roof glows with the reflected energy of the sun, while paint is just paint.

*The Road to Tequis,* 20" × 30"
This old Mexican church was a very paintable subject with its various planes of light and shadow. The Mesquite trees add a softening effect to the ridged planes of the church. Notice how the roof as well as the road are gradated in value and color to add depth and feeling.

### Reflected Light in Shadows

Light from the sun and sky is not only reflected toward the eye; it also bounces into nearby shadows, warming them, lightening their value, and giving them a transparent quality. You feel as if you can see into them. That's a function of light: Wherever the sun can't get to directly, sky and reflected light will. Otherwise, shadows would be pure black. Nighttime is a different situation, of course, for moonlight is a reflected form of sunlight and is very weak. By the time it gets to earth, there's little energy left to bounce into the shadows. Shadows on a moonlit evening are therefore very dark and contain no visible detail.

During the daytime, however, the only black shadow is in your pocket. When I was a student, I did a picture of an Arab merchant standing in front of the door

*Old San Miguel, Mexico,* 16″ × 20″
This old Mexican church offers a wonderful opportunity for interesting shapes and textures and at the same time conveys a strong light effect. I welcomed the rich darks of the trees, and although the shadow sides of the church are as dark as possible, there is still reflected light in them.

to his shop. In order to make the shop front look white and brilliant, I painted the interior black. When my teacher looked at the painting, he asked me if the man could read a newspaper inside his store. Of course, there had to be reflected light inside the shop, and I immediately saw that the door was like a dead hole in the canvas. At the beginning of this chapter, I said that darks should not have too much light in them, but neither should they be heavy and opaque.

Sometimes, it may be necessary to make arbitrary changes in shadows; that is, a shadow on a white house will sometimes *look* very dark — even black. But, again, light is one thing; paint, another. Nature gets away with strong contrasts because its darks are rich and its lights are full of energy. Unfortunately, students see these strong contrasts and try to copy them literally, unaware of the limitations of the palette.

*Montclus, France,* 24″ × 30″
This is a medieval village in southern France. The afternoon sun from the above right made a beautiful effect. The scene was quite different and dramatic due to the fact that in looking down, the valley wall beyond obscures the sky, causing the buildings to stand out in sharp relief and furnish a natural center of interest. It is important with subjects like these to minimize the windows, so they are felt, rather than seen.

## VARIETIES OF LIGHTING

Having discussed certain technical aspects of light, I should briefly mention the characteristics of the kinds of lighting generally used by outdoor painters.

Of course, the most familiar form is sidelighting. The sun strikes objects from either the right or the left, and the resulting shadows are valuable for patterning a picture and also for defining forms.

Frontlighting, in which the viewer is looking away from the sun, flattens objects. There's lots of color with this kind of head-on light, but fewer useful shadows.

Backlighting (the opposite of frontlighting) produces great value contrasts and simple masses, but little color, since you are looking toward the light source.

*Woodland Stream,* 16″ × 20″
This stream was painted on a bright gray day. Since the source of light is diffused through the sky overall, the top lanes receive the light. I've kept the woods and trees as a simple dark mass relieved by a few details. As with most subjects, I chose only the rocks and other details most needed to make a satisfying composition.

## THE GRAY DAY

Students think of gray days as dark and ominous, and paint the sky accordingly. But since the sky holds the light on a gray day, it's really full of energy. Imagine a glass door to an office. If the office is illuminated and the glass is clear, the light goes right through it. You can see everything that goes on in the room. But if the glass is frosted, like the sky on an overcast day, the door becomes a bright, luminous rectangle. I usually ask students to stare at the ground on a gray day. When they suddenly look up at the sky, they involuntarily squint. That shows how much energy radiates from a gray sky. You don't squint when you look at a blue sky. If you hold a white canvas against a gray sky, you'll see that the canvas looks dark in comparison.

The key to painting a gray day is to understand the brilliance of the sky and to see how it does two things: First, it throws a silvery light down onto the top surfaces of all the earth planes; and second, it acts as a light foil against which the planes of the earth, buildings and trees form a dark silhouette.

*A Hopeful Gleam,* 12″ × 16″
Gray days are often exciting when a weather front is passing, as in this painting. It gives me a chance to use purer colors and contrasts. Since the breaking light is the only source of light, it is the lightest note, relieved only by the tin barn roofs. To preserve the luminous sky, even the darkest clouds are kept from being too heavy.

## EMPHASIS

Although I've talked a lot about the physical characteristics of light, remember that there will always be times when you'll want to change what you see in order to get closer to the psychological truth of the subject. For example, atmosphere dulls color and value, but inattention to an area can also make it less vibrant. If you were to take two white business cards and hold them the same distance in front of you but about a foot apart, whichever card you stared at would look whiter than the one seen with your peripheral vision. Even though they were the same distance from you, they'd change in appearance, depending on which one got your attention. Similarly, if I were to talk to you as I walked around a room, you would look at my head and never notice what was behind me. You wouldn't be interested in the background, and you'd see it only when you stared at it. A background should always be painted so that it remains a *background*, subordinated to the elements that are the real subject of your painting.

## BREAKING THE RULES TO CAPTURE AN EFFECT

There's also the question of the painter's emotional response to a scene—a most important part of painting. When I began to paint, I was very academic, just as a student should be. I handled values in a naturalistic and methodical way. I always located my darkest dark and lightest light in the foreground and never contradicted the rules of atmospheric perspective by having anything as dark or as light in the middle or far distance. But today, I don't hesitate to break such "rules." If a distant, sunlit sail looks like a sparkling jewel to me, I don't contradict my emotions by surrounding it with "atmosphere." I don't throw excitement out the window simply to adhere to "correct" academic rules.

Similarly, there are days when parts of a very clear blue sky, glimpsed through massed yellow foliage, look like dark sapphires. But you can't paint the sky that color. The sky is full of energy, and even if you were to match the value and color perfectly on your canvas, you'd never get the luminous quality in paint that you feel so strongly in nature. It would just look dead and gaudy. That's why, when I paint fall trees against a bright blue sky, I usually raise the sky's value. I also gray it somewhat, so the red and oranges have more quality. Again, I contradict the "facts"—knowing, in this case, that although I'm excited by an aspect of nature, there's no way I can actually capture certain visual effects on canvas. Part of being a professional is knowing what *can't* be painted!

Finally, there are certain situations in which the very life of a picture contradicts all our hard-won knowledge. For example, I once saw a painting of a man wearing a huge, flowing white tie. I liked the head, but felt that the tie was a distraction. Yet when I blocked out the tie, the head became commonplace. These elements contradicted an obvious rule of composition, but together they also gave the picture strength and individuality. The same thing sometimes happens in landscape painting. You like a picture, but as you study it, you find parts that don't seem logically right. Spots of color are in the "wrong" place. Values aren't accurate. But by correcting every flaw, you might lose the sparkle and vitality of the painting. In some indefinable way, the strangeness of a picture can often be an essential part of its charm.

*Photo of scene*
This photo of the scene has promise but lacks
artistic judgment or interpretation.

*Capri Harbor, Italy,* 20" × 30"
Waiting for the ferry to the mainland, I painted an 8" × 10" oil sketch to catch the essentials of this
scene. Back in my studio, I drew on emotional memory to paint this larger version. There was a
rich, late afternoon sun entering from above right, striking only portions of the headland and boats.
This left a good portion of the painting in luminous shadow. I created a foreground at left for
interest and to lead into the picture. The painting, while not literal, speaks of the charm and character
of the subject.

# PORTFOLIO OF LIGHT & COLOR

We have discussed some of the basic principles of painting light. The following field sketches demonstrate how to put these ideas to work.

*Segovia, Spain,*
*10″ × 14″*
Painted at midday outside the city wall, these old steeples and buildings furnished a striking silhouette against a very pale sky. Note the reflected light in the building shadows.

*Half Dome, Yosemite,*
*10″ × 14″*
I awoke one morning to find a fresh dusting of snow had fallen, giving me a welcome opportunity for a painting change. The day was gray but bright. The dark pine tree offered the perfect foil to push the mountain into the distance and enhance the feeling of atmospheric progression.

*The Almalfi Coast, Italy,* 10″ × 14″
This was painted from my hotel balcony. The scale of such a scene is impressive and difficult to capture in paint. I simplified as much as possible and paid close attention to the sensation of atmospheric progression.

*The Back Road, Taos,* 10″ × 14″, watercolor
When I work in watercolor, all artistic principles and thought processes remain the same. Here, I was attracted by the way the large cottonwood tree contrasted with the other subject matter and pushed it back. The house is a typical shape, built of adobe.

*Along Cape Ann,*
*10″ × 14″*
The rich afternoon sun made an appearance after a day of gray skies. There was only moderate surf activity, but the light and anatomy of the warm Cape Ann rocks caught my interest.

*Yosemite Falls, 10″ × 14″*
This was painted in the early morning light that bathed the facing cliffs in intense light. The ground was still in shadow, making a useful dark screen that gave the light cliffs added luminosity and atmosphere.

**The Peacock,** 30″×24″

I enjoy still life subjects as a change of pace from outdoor painting, which is quite different. However, the principles are exactly the same, only the shapes are different. Here I kept all the material related to give a sense of unity. The light was from the left, and this was kept foremost in my mind throughout.

**The City Gate, Lucerne, Switzerland,** 10″×14″

This scene was painted on a gray day with an occasional slight drizzle. The spires were most attractive against the light-filled sky. I felt that this was the central interest, so I edited the trees and surrounding material to contribute, but not take over.

# PART FOUR
# PAINTING IN ACTION
## 13 DEMONSTRATIONS

The demonstrations that follow represent my regular painting sessions on location and in the studio. My hope is that they will provide an understanding of the thinking processes that an experienced painter uses in translating nature into paint. In most cases it is not possible to give exact color mixtures, only the general character of the various colors. I have tried to convey, in the most direct way, the process of putting a painting together from conception to finish.

*Folly Cove, 20″ × 24″*

# PAINTING THE COLOR OF SNOW

### Step 1: Wash in a Complementary Ground

First I wash the canvas with a dull orange mixed with turpentine (no white added). This mixture counteracts the tendency to paint too blue where snow subjects are involved and subtly adds vitality and vibration to the overall finished work.

I then proceed to draw and mass in the general composition, using thin color so changes can be made if necessary.

### Step 2: Paint the Sky

Since I am looking away from the sun and the lighting is rather flat, I paint the sky a darker value. It appears still darker due to the presence of white snow. Three basic colors are used: cadmium red medium, phthalo blue and ultramarine. White is used to attain correct values. At the horizon, red blends into phthalo blue. To create vibration, bits of all three tones appear throughout the sky, rather than leaving solid bands of color. The clouds are a dull warm gray so they won't compete with the snow.

## Step 3: Model the Distant Rocks

Next I model the rocks in the distance, using yellow ochre for the lights and a gray-violet for the darks. I paint back and forth, scraping and changing shapes and design, keeping the entire painting in a state of flux. The introduction of new elements influences everything else, and unity must be maintained in the total effect.

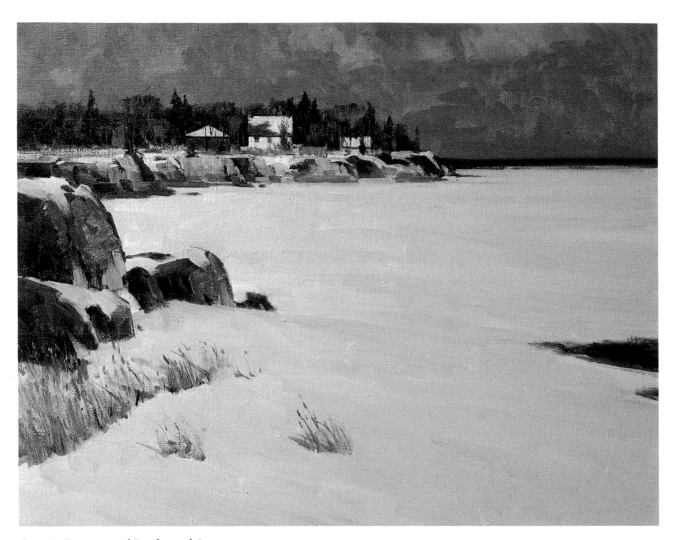

## Step 4: Foreground Rocks and Snow

Foreground rocks are painted using the same basic colors, but stronger in value and chroma. The color and value of the snow are affected by the angle of the sunlight, which does not fully illuminate the snow. It is therefore painted a pale gray-blue, influenced by the sky color. I keep it as light as possible, making certain my lightest light will still show up against it.

## Step 5: Add Footprints and Other Details

The footprints are indicated with pure white, warmed with a slight touch of yellow. The prints are light and throw small cast shadows, since their plane faces the sunlight. Figures are added. Then I go over the entire painting, correcting values and adding accents where needed to pull things together. When making these adjustments, I step back often to view the total effect.

The colors used for the distant trees and foliage are mostly earth tones: burnt sienna, raw umber, and, for the evergreens, black and medium yellow to make a dark green.

This painting is effective due to the large expanse of white and the strong pattern contrasts.

*Niles Pond,* 24" × 30"

# ADDING VARIETY WITH ACCENTS AND DARKS

### Step 1: Indicate the General Composition

This is a studio painting based on an 8″ × 10″ oil sketch I did in the field (above). I wash in the entire canvas, indicating the general composition and approximate colors. Because I'm looking away from the sun, the effect again is flat light. As a result, the colors are rich, and there are very few cast shadows, but strong accents and darks.

### Step 2: Adjusting the Colors of the Sky

I start indicating houses, bare trees, and the sunlit rock outcroppings, using a yellow ochre base. The sky is mostly gray with only small patches of blue. The gray, which is darker at the horizon to indicate heavier atmosphere, is slightly reddish. The overall tones of gray are ultramarine with a touch of cadmium red medium. The trace of clouds are yellow ochre and white, grayed slightly with the gray tone. I am always aware when painting any portion that it can, and will, be adjusted as I go along, trying, as it were, to paint the entire painting all at once, rather than section by section.

## Step 3: Painting the White Notes

I cover the water area with paint, leaving the final colors for later. I then paint the very white notes of the boats. The wharf and two skiffs were not in the scene; I invented them as a pictorial necessity. They are painted equally white; however, a trace of yellow brings them forward. The slight cast shadows on the right are very dark, as they are under the pilings. I used ultramarine and burnt sienna on the slightly warm side for these. The original dark wash, although transparent, still shows in spots, which adds variety.

## Step 4: Work on Color, Value, Shape

The water is laid in with a dark band of ultramarine at the horizon giving way to a calmer, smoother surface in the foreground. Variations in the flat plane of the water are indicated by a pale pinkish color broken by various tones of blue with greener tones nearer the foreground. I paint the land with a mixture of ultramarine and cadmium red medium, then I work various greens into it. I make various adjustments of color, value and shapes, until it feels right, then I add small details such as sea gulls and sails.

*The Blue Cove,* 18" × 20"

# PAINTING RICH COLOR IN A STILL LIFE

### Setup

I knew I wanted a rich, colorful painting, so I chose colorful fruits and used neutral and softer colors for the rest of the composition.

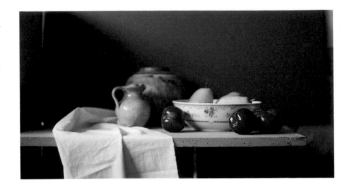

### Step 1: Charcoal Sketch

I started with a charcoal sketch in this case to be certain of my composition.

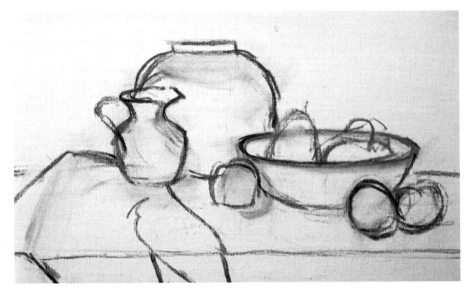

### Step 2: Initial Lay In

Approximate colors are laid in thinly so I can easily wipe out and rearrange things. A warm background is laid in using burnt sienna and Mars black, indicating that the source of light is at the left.

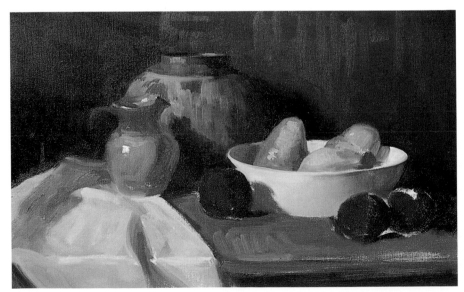

### Step 3: Creating Luminous Light

The fruit is painted with indications of the shadow sides. Small, well-placed reflections on the shadow sides help convey a luminous light effect. I use ultramarine for the white cloth, raw sienna for the shadows, and a touch of the same for the tone of the cloth, leaving a purer white for the few highlights.

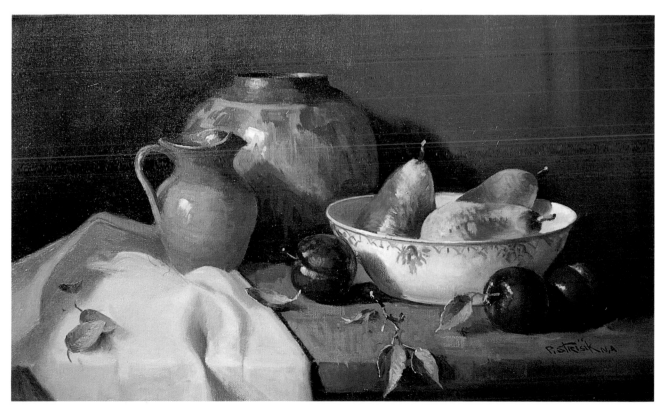

### Step 4: Adding Detail

In the final session, the design on the bowl and the leaves are added, which loosen up the otherwise rigid forms of the general composition.

   Still lifes are a refreshing change from outdoor subjects. The principles of painting, however, remain the same—whatever the subject or location may be.

*Pears 'n' Plums, 12″ × 20″*

# MAKE SHADOWS GLOW WITH REFLECTED LIGHT

## Step 1: Preliminary Drawing and Wash In

This beautiful Venetian church has inspired countless painters throughout the ages. I have painted it from many angles and have always enjoyed the challenge.

I begin with a careful charcoal drawing, due to the subject's complexity. I then go over the drawing with a warm gray and wash in some of the general colors, including the sky.

## Step 2: Planning Luminous Shadows

I change the sky to show some blue and the direction of the elongated cloud. I also start putting more paint on the church and buildings since I am now more certain of the general composition. Most of the church is in shadow, so to avoid an uninteresting subject, I plan to make the shadows luminous and full of reflected light. For now, I use a gray-blue of medium value. I compare this value to touches of pure white, so I can make the shadow as light as possible, still leaving room for good contrast with the sunlit portions.

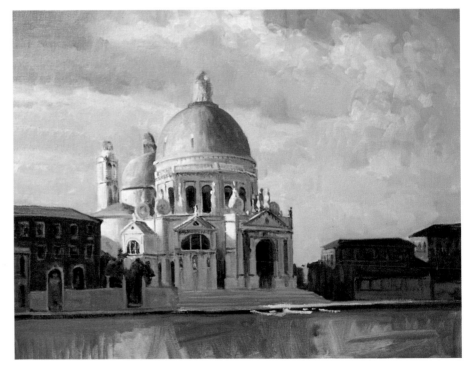

## Step 3: Refining the Color of the Sky

At this stage I paint over the entire canvas, refining shapes, color and values. The clouds are warm white, but grayed somewhat to keep their place; the horizon clouds are a warm gray-violet, and the sunlit clouds above the horizon are warm with orange. The sky in this painting speaks of a warm, late-in-the-day atmospheric effect.

## Step 4: Adding Detail

I have a better feel at this point for the paint and texture. Boats and water are added. Details and accents are put in with careful judgment.

## Step 5: Warming Touches

In the final stage, I go over all the lights, including the clouds, warming them a bit. And to achieve the feeling of light and luminosity, I work yellowish tones into the shadow portions of the church, representing reflected light.

*Santa Maria della Salute, Venice,* 24" × 30"

# CAPTURING THE MOOD AFTER A RAIN

## Photo

This scene in northern Maine inspired me to try to convey the feeling of freshness left after a rain shower. The sky is clearing and a low warm sun prevails.

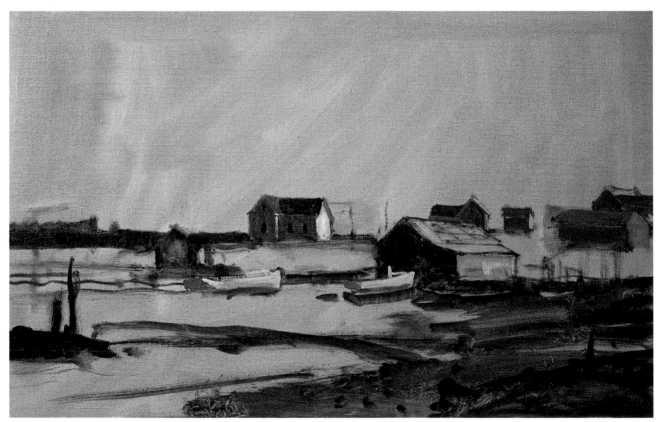

## Step 1: Blocking in the Masses

I want a warm effect of mud at low tide and light on the boats and buildings. I wash the canvas with burnt sienna and block in the masses, drawing with burnt sienna and ivory black in a transparent manner.

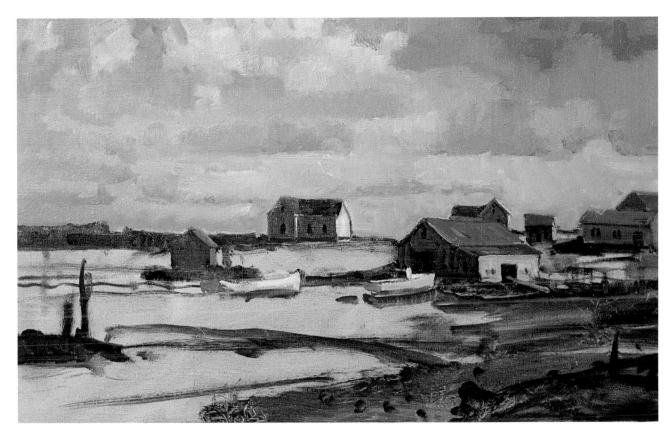

## Step 2: Painting Clearing Skies

Next I turn to the sky, which contributes much to the mood of clearing skies after a rainstorm. The blue is phthalo blue plus yellow ochre and white at the horizon, giving way to ultramarine in the upper portion. The clouds are a gray-violet of ultramarine and cadmium red medium, with a more reddish feeling at the horizon. The light clouds are yellow ochre as they move lower in the sky, becoming pinkish orange at the horizon.

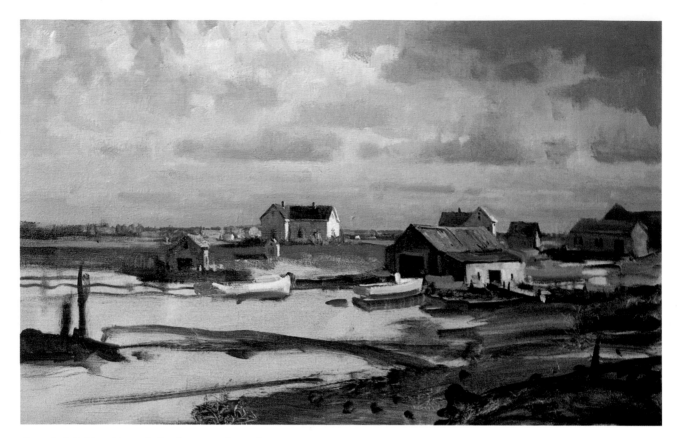

## Step 3: Making Use of Shadows and Darks

I proceed to paint the landscape and buildings. The white of the houses and boats has a yellow cast. Shadows are painted a bit darker than usual, but not so dark that a darker window or opening won't contrast. The shadow of the distant white house has a bit of ochre reflected light with blue near the top for the sky influence. The fish houses, being weathered wood, present a good opportunity for rich darks. I use a cloud shadow to good advantage, so there is less emphasis on the buildings on the right and in the distance.

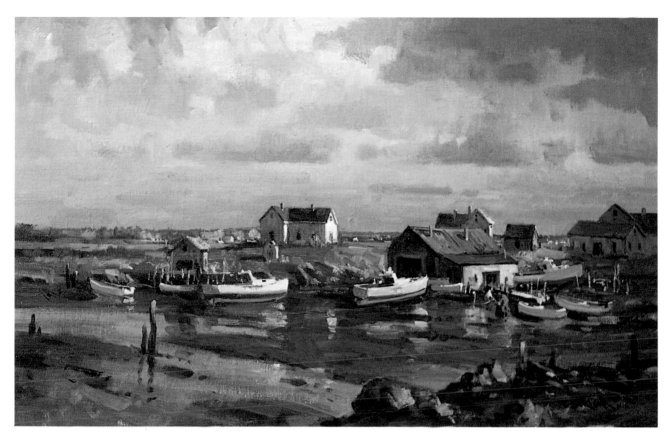

## Step 4: A Shrinking Light Effect

For the wet mud and water I use ultramarine and cadmium red light on the warm side. I paint the light striking the rocks, buildings and boats with as much punch as possible and boost this effect with strong accents of ivory black and burnt sienna.

*Whale Cove, 16" × 24"*

# CAPTURE THE POETRY OF A PLACE

## Photo

This photo shows a typical scene in Maine, but there are many elements missing that would have conveyed a better sense of the place. This is a good opportunity to show how you can use a scene as a starting point and, with some judgment and imagination, bring to the viewer the real flavor and poetry of a place.

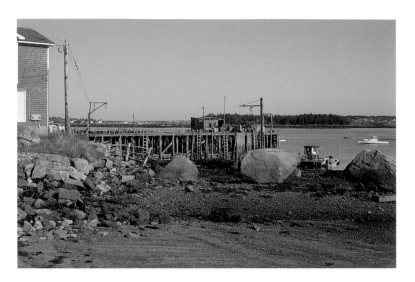

## Step 1: Rough Drawing and Wash In

I begin with a rough drawing, washing in general colors to have something to relate to as I proceed to paint more solidly. It is a bright sunny morning, the air is dry and crisp, and the colors are rich and clear.

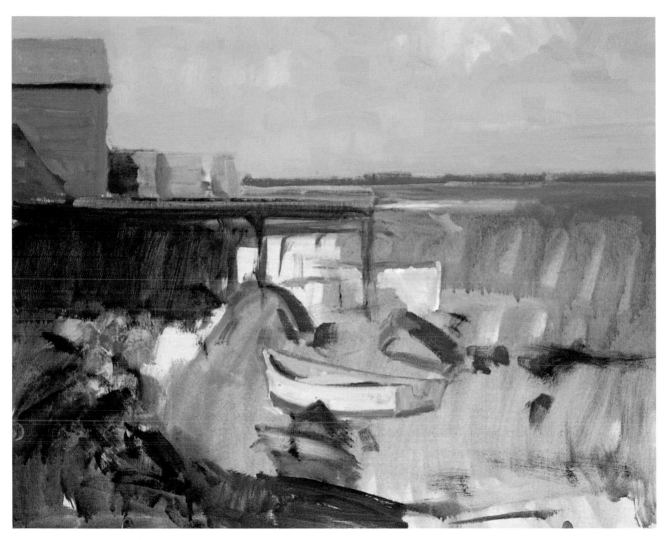

## *Step 2: Color and Value*

I lay in the sky with phthalo blue and yellow ochre—a bit reddish at the horizon—and a touch of ultramarine at the very top. The clouds are yellow ochre and white. There are many ways to mix all colors; the value is the important element.

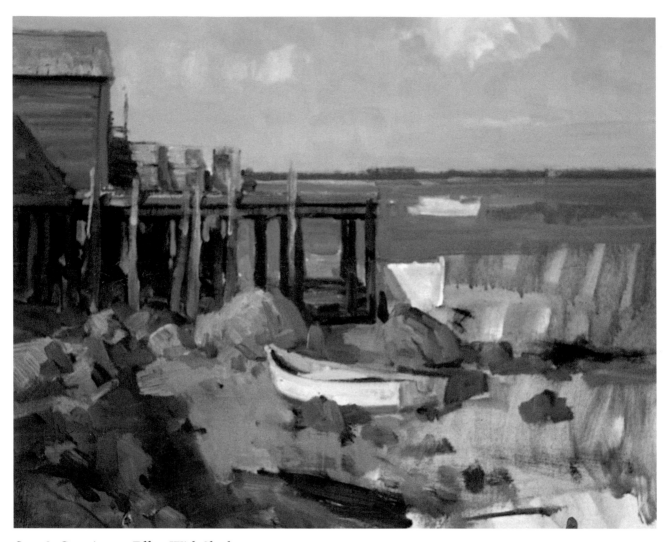

## Step 3: Creating an Effect With Shadow

I create an arbitrary shadow on and from the rocks at left, strengthening the lights. At this point, I feel I can best develop the effect back in the studio.

## Step 4: Conveying a Sense of Place

Back in my studio, I am free to bring to the canvas an emotional remembrance. I create contrast by making the sunlit pilings very light and the area under the wharf a rich, dark, warm shadow of reddish violet with accents of ivory black and burnt sienna. The water is a variation of the sky color with a bit of ultramarine in the distance. The sand is gray-pink, varied with other tints, but keeping them of the same value. I add characteristic additions to better convey the sense of place—in this case, boats, lobster traps and sea gulls.

*Woodwards Wharf*, 16″ × 20″

# PAINTING THE GREENS OF THE COUNTRYSIDE

*Photo*

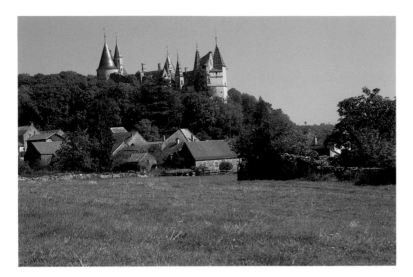

This French countryside castle with its typical cone shaped roofs was a most interesting and certainly different subject for me. I also liked the cluster of red-roofed houses at the bottom of the hillside.

*Step 1: Blocking In the Composition*

After studying the subject and doing a bit of mental painting, I block in the general composition. The idea is to try for near-correct values and eliminate the distracting white canvas.

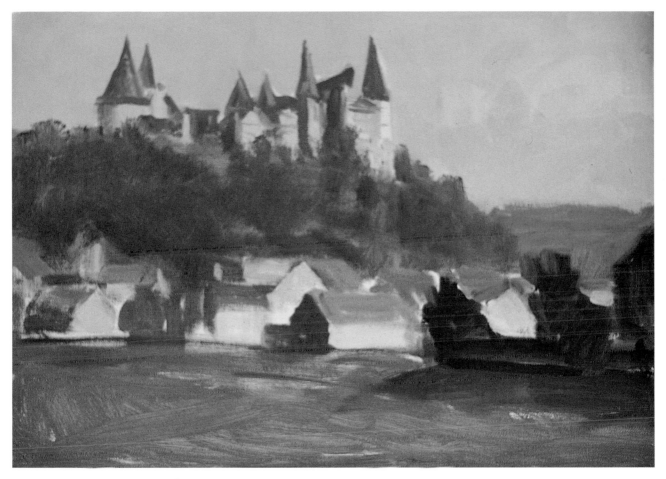

## Step 2: Painting an Atmospheric Effect

I paint the sky a very light gray-blue since the humidity causes the atmosphere to hold moisture, which reflects the sunlight. I also put a light tone on the castle. The shadow is a gray-violet of ultramarine and cadmium red medium. In all mixtures, a bit of white may be used.

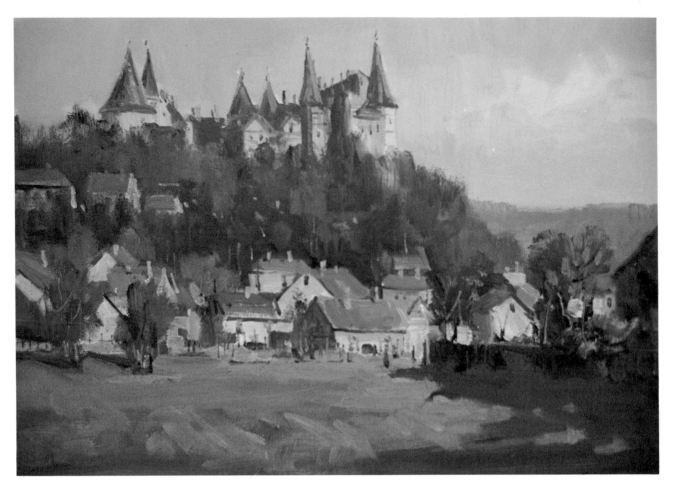

## Step 3: Making Adjustments

In a sense, the painting has *already* been painted—since the first conception and lay-in. The remaining work is to make adjustments and exercise personal judgment. It is my custom with quick field sketches to stop painting after the statement is made and enough information has been gathered. I then use these notes for further paintings at a later date in the studio.

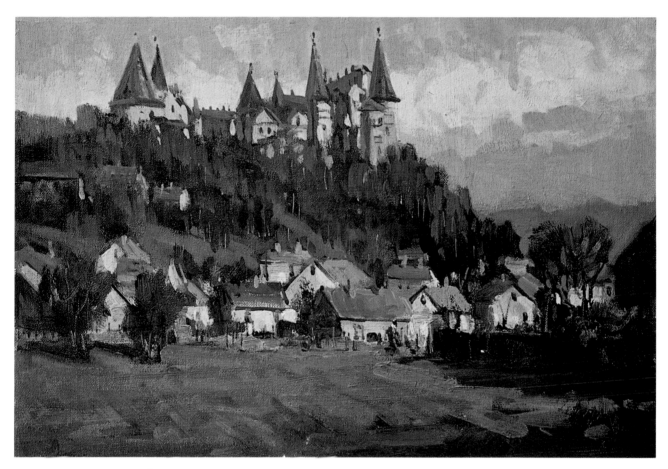

## Step 4: Finishing Touches

In this case, I decide to finish the painting in the comfort of my hotel room. First, I repaint the sky for a more interesting pattern and color. I use a gray-violet bank of atmosphere at the horizon with lighter clouds rising from it. I strengthen all the greens, suggesting foliage without detail. Though a seemingly small part of the composition, the intense rich darks in the right foreground serve to reinforce the sunlight, bringing the foreground forward. I avoid the overly intense green grass, varying it instead with touches of warm pinks and ochre.

*La Rochepot, France,* 10" × 14"

# ADDING DRAMA TO THE COMMONPLACE

*Photo*

This scene illustrates one of those instances in which the composition and overall effect in nature needs little revision. All that's necessary is to emphasize those features that can add drama, or at least avoid the commonplace.

## Step 1: Creating a Composition

First I apply washes to work out the composition. In this composition, I see a perfect opportunity to intensify the sunlight by creating a dark mass on the left.

## Step 2: Adding Touches of Autumn

I place a few farm buildings at the center of interest and lay in the sky with light green-blue and clouds of a warmish tint. The hillside is laid in with touches of autumn colors and dark green accents representing pines.

## Step 3: Painting a Center of Interest

I continue to paint the hillside, going back and forth, blending, reinforcing colors and values. I lay in the rich darks of the left bank and simplify the trees into a few evergreens and taller trees as needed.

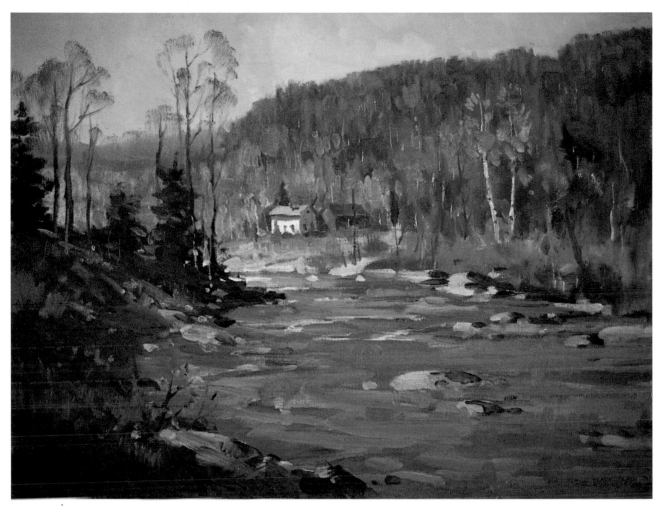

## Step 4: Painting the Moving Water

To finish, I paint the moving water bluer in the distance and greener in the foreground. I place very light rocks (white with a bit of yellow ochre) on the opposite bank and in the water. I go over the entire painting, adding accents where they are needed and adjusting values and colors to achieve an overall unity and to enhance the center of interest.

*Perkin's Bend*, 16″ × 20″

# FINDING AN ORIGINAL VIEWPOINT

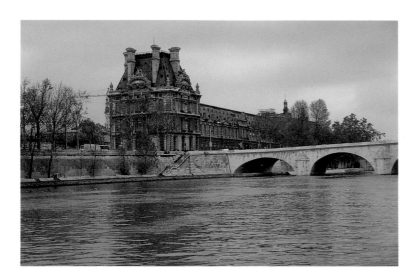

## *Photo*

Being fond of bridges, I could not resist this view of the Louvre. With permission to paint from a dock, I set up my 10″ × 14″ box and tripod. The resulting field sketch was used later in my studio as the basis for the finished painting.

### *Step 1: Starting With a Suggestion of the Subject*

After I started, the sun came out and gave me a welcome opportunity for a more pleasing effect. I drew in the subject with a brush and raw umber, freely suggesting the anatomy of the building and windows.

## Step 2: Defining Light and Shadow

Here I start with color, defining the light and shadow portions of the Louvre. I plan to use yellow ochre with white as a basis for the lights and a gray-violet mix of ultramarine and cadmium red light with white for the shadows. The bridge, "Pont Royal," is in half light and appears quite warm. At this point, I give a thin wash of color to the water.

## Step 3: Working the Whole

I continue working on all parts of the painting, bringing out details, but being careful to keep them only suggestions, without sharp edges. I apply, in broken color, a thin hint of light blue on the shadow side of the bridge to suggest sky influence. Since the river is flowing, the reflections are not as mirrorlike as they would be on calm water.

## Step 4: Adding Detail

I add the autumn trees and some activity, such as boats and figures on the bridge. The addition of the lacy trees softens the hard lines of the building. These are scumbled in lightly, with trunks and branches merely suggested. I considered the painting complete at this point; however, the sky troubled me.

## Step 5: Perfecting the Sky

I decided that a different sky was needed to complement the subject. After several tries, I painted this one. This additional effort presented the opportunity to go over the shapes and values, unifying the effect of a pleasant afternoon in Paris.

*The Louvre, Paris,* 16" × 24"

# PAINTING THE EFFECTS OF CLEARING SKIES

### Photo

This is a typical scene in northern Vermont. The sky is clearing with bright spots of light. The landscape is wet and rich in local color.

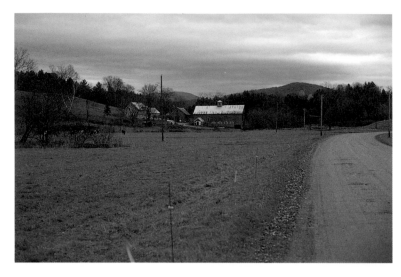

### Step 1: Painting Clouds and Breaking Light

I quickly wash in the general composition and colors so I can paint the sky in proper relation to them. The cloud forms are a delicate gray-violet and, where the light breaks through, pure white with a touch of pale yellow.

## Step 2: Color Choices for Atmospheric Perspective

I paint the distant mountain a light gray-blue, the closer one a reddish violet-gray. The row of dark pines behind the farm is painted with black and medium yellow. I add a few touches of cool green here and there. The tin roofs' silvery light adds a sparkling effect. A few streaks of rust keep them from being too solid. The white houses are painted gray, just dark enough not to compete with the bright sky, which is the main light source.

## Step 3: Varying Color and Texture

The meadow is painted a rich green, cooler in the distance. Touches of pink and ochre keep it varied in color and texture, particularly in the foreground. Gray rocks are added. I take advantage of the small brook at the left, using it to lead the viewer in and to add variety. I also add cows for further interest.

*Clearing Skies, Vermont,* 16″ × 20″

# HANDLING DETAIL IN A BACKLIT SUBJECT

### Step 1: Washing in the Pervading Tone

A dull red-violet tone pervades the subject, so I lay in the drawing with a wash of ultramarine and cadmium red medium.

### *The Artist on Location*

My vantage point for this painting is on the bridge spanning the Yonne river in the French village of Auxerre. I am looking almost directly into the late sun, creating a strong backlit silhouette.

### Step 2: Creating the Light Effect

Since I am looking into the light, I paint the sky with light yellow ochre, a hint of phthalo blue and white. I start to model the buildings with a yellowish tone and variations of my original red-violet. My aim is not to get too caught up in the drawing and all the details, but to create a light effect, which attracted me to this subject. If the light had come from the front, the details would have been overwhelming, and the striking silhouette would have been lost.

## Step 3: Telling the Poetic Truth

I edit the tree pattern for variations and open the center portion to include some human activity. The trees are dark green with a strong top light. The flat plane of the sidewalk gets full sun. It is consequently very light, even lighter at the center of interest. I make necessary adjustments to value and shapes. I have not slavishly followed the photograph, but picked out only those parts of the scene that I needed for the effect I wanted. This results in a poetic truth rather than a photographic truth.

*Saint Etienne, Auxerre, France, 10″ × 14″*

# IMPROVING ON YOUR SUBJECT

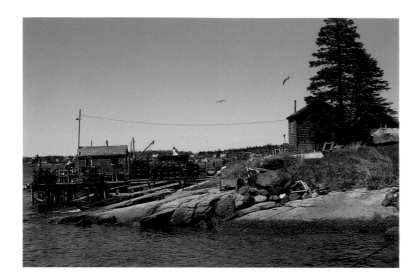

## *Photo*

The interesting material in this scene is scattered about with no coherent design. My challenge was to pick and choose the most interesting and characteristic features.

## *Step 1: Developing a Composition*

I depart from the usual horizontal format and choose a vertical one. I decide to concentrate the interest in the upper portion. The composition is established with broad washes of approximate colors.

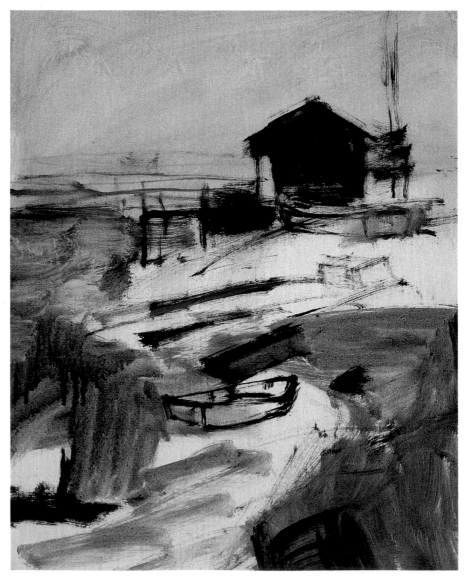

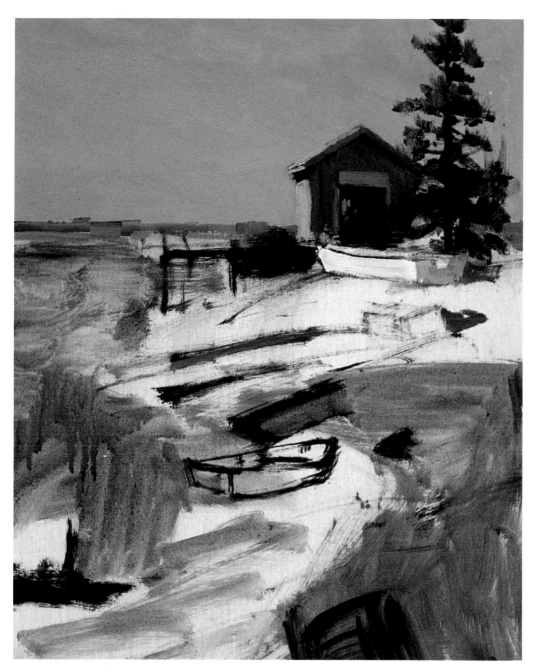

## Step 2: Using Rich Darks

The sky is laid in with a greenish blue made up of phthalo blue, white and yellow ochre, with pinkish clouds. The tree is ivory black and cadmium yellow. I want a strong silhouette against the sky, so I keep my darks rich, but not so dark that I cannot make a darker note, such as the open door.

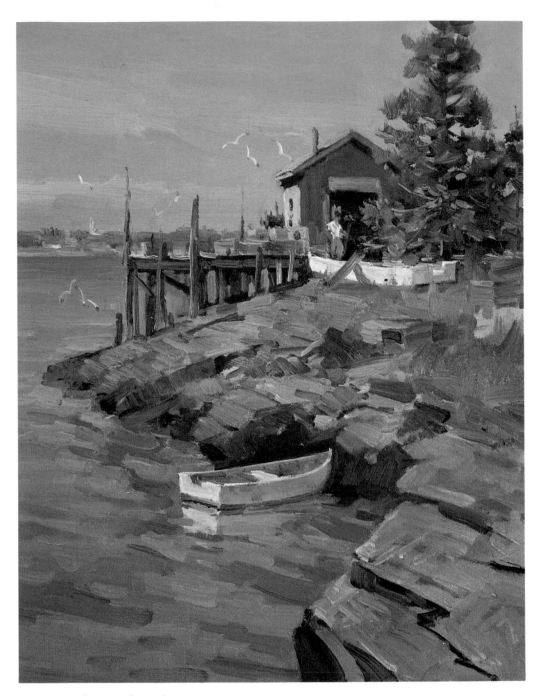

*Step 3: Making Color Adjustments*

I make adjustments in color, value and shapes as I go along. The water is generally the sky color with touches of green in the foreground. The rocks are tones of yellow ochre and white with variations of burnt sienna. The darks in the rocks are burnt sienna and black with some violet tones.

## Step 4: Make a Personal Statement

Back in my studio, I exercise my artistic judgment as to what is still needed. This emotional remembrance lends itself to a personal statement. I make the fish house red and repaint the sky with cleaner color and more interest. I repaint almost all of the painting with fresh color; make some minor compositional changes, mainly in the foreground; and push the wharf back to show more water beyond. I finish up with characteristic details such as boats and lobster traps.

*The Red Wharf,* 20″ × 16″

# THE SPARKLING EFFECT OF TOP LIGHT

### *Photo*

This photo of the subject is not very interesting; however, I am in a boatyard with interesting material all around me, so I use whatever I wish to convey a more interesting impression.

### Step 1: *Washing in With Direct Colors*

I wash in a general composition with approximate colors. To capture the effect of top light, I add sparkling light on the roof of the red shack. The trees form a dark silhouette against a bright greenish blue sky.

## Step 2: Developing Trees and Sky

The sky is broken up with light lavender clouds highlighted with touches of very light orange plus white. The trees are developed and shaped by the use of sky holes, and touches of green are added without losing the silhouette.

## Step 3: Adding Interest

The distant water cannot actually be seen from my vantage point, but it adds great interest. Various boats and rain puddles are placed about. I paint the foreground with yellow ochre, touches of terra rosa, and white.

## Step 4: Adding Accents in the Studio

Back in my studio, I freshen up colors, adding accents where needed. The light effect is one of an almost overhead sun, so all vertical planes are in shadow and all top planes receive a strong top light.

*Essex Boatyard*, 16″ × 20″

# CONCLUSION

I began this book with a brief discussion of the duties of the teacher. I'll end it with a few words about the responsibilities of the student.

The primary thing you should concern yourself with—whether your subject is a landscape, portrait or still life—is good painting. A portrait is no more difficult to paint than a landscape, and a landscape is neither harder nor easier than a marine picture. It's all painting. Unfortunately, many students want to break painting into categories. They study trees with so-and-so, portraits with somebody else, and flowers with yet another painter. Yet they should really be applying themselves to more fundamental questions. Frederick Waugh, the great marine artist, painted the sea with unequaled power and freshness, but he was also a fine landscape and figure painter. Though he loved the sea, he also applied himself to the general business of painting. He learned his craft.

Since we naturally love pictures, museums, and the work of our teachers, we're easily influenced. We paint pictures not from nature, but from the memory of pictures we've seen and liked. As a student, you may do fifty paintings, and if you're lucky, two or three will have something in them that is uniquely your own. When you study under a teacher, you're bound to paint the way she does. I laugh to myself when students worry about losing their "originality." Set your mind at ease. Henry Pitz once said that imitation is an essential part of learning; it's as important in walking and talking as it is in training for the Olympics. Influences, in fact, are essential to finding your own way in painting. I often wish I'd had more opportunities to talk to other painters when I was a student. For ten years, I worked almost in the wilderness, never knowing whether I was on the right track or not.

So don't take your student work too seriously. Think of it as practice—something to be put on the shelf eventually. In short, be prepared to be a student. Many students are impatient and don't want to serve their apprenticeships. They are anxious to enter shows, win prizes and sell their pictures. But all great painters began as students—and, more importantly, *remained* students throughout their lives.

Hard work and determination make the painter. Talent isn't that important. In fact, I dislike the word, for it suggests that if you're born with ability, you can achieve great things without working. Talent makes life easier, but as Leonardo da Vinci said, it doesn't guarantee success. It's like the grease on a wagon's wheel: The grease makes it easier to get to town, but you can still get there without it— you just squeak more along the way!

For every bit of energy your teacher expends in class, you have to use a thousand times more. There are no magic formulas, just motivation and determination. If a student really loves good painting, he will walk ten miles to find an answer to a problem.

Of course, it's possible to paint industriously every day and still just make "pictures" of things. Work long enough and you'll get a resemblance to your subject, but that's just painting to paint. You want to direct your energies. And

*Island Church, Mikonis, Greece,* 16″ × 24″

This is a typical church commonly found in the Greek islands. These churches are wonderful to paint due to being white and filled with reflected light in the bright Greek sun. In this painting I was looking into the sun, which was almost overhead. This created a strong top light on the flat planes. The sky was kept very light, but just dark enough to allow the white sunlit portions of the church to register. The darks in the trees and stone wall are a welcome contrast.

that comes with the desire to excel and understand good painting.

It's this knowledge — that elusive quality called "taste" — that gives a picture the dignity common to all fine things. In the complex business of painting, the difference between good work and a masterpiece is often very slight. But this difference shows the hand of the master. That's why a picture of a grand subject can leave you unmoved, while a painting of a simple motif, deeply felt and properly expressed, can bring tears to your eyes.

Some students wait for the teacher to tell them what to do. They yearn, as they often say, to be "only half as good as the instructor." The other kind of student tries to understand the principle behind the teacher's words and then applies it. One walks in the footsteps of other painters; the other is on the same road, but finds her own way.

*Sparkling Light,* 16" × 24"

I used to tell students at my workshops that their paintings wouldn't necessarily improve during the two weeks we were together. In fact, they might even get worse. You may have the same problem after reading this book. The reason is obvious. At home on your own, you work in a comfortable and familiar groove. There's no one to kick you, no one to open a new gate and push you through. When you begin to learn, however, your mind is stirred up. Your old formulas no longer seem valid, and you start to have trouble. Don't worry about it. Once it's in your head, even the smallest idea can be powerful. But it takes time for it to get onto your canvas. The knowledge you get from teachers and books is like the parts of a jigsaw puzzle. You know the parts are valuable, but you don't always know what to do with them. Then, one day things fit, and you discover where the odd piece belongs. That's why one reading of a solid book in instruction is

*Venice,* 20″ × 30″

*October Afternoon,* 8" × 16"

never enough. It must be read and reread till you fully understand what the teacher is saying. Students skim over many important ideas, thinking that they've read them before. They may have—but did they understand them? My favorite books are worn and thumbmarked. As a student, I read John Carlson's book, *Landscape Painting,* fifteen times, but I can still pick it up and find passages that seem new to me. Between readings, I've learned more, and each time I return to the book, I can better appreciate what Carlson is trying to say.

Painting has a practical side, a side of common sense and judgment that parallels much of what students have been experiencing all their lives. Have you noticed, for example, that there are no child prodigies in painting? They exist in music and mathematics, but not in painting. Painting is the sum total of the human being. At seventeen, a person may have a phenomenal technique, but technique has little to do with the power of conception. That takes experience, not just painting experience, but sadness, happiness—personal reactions to the general business of living. Nature can move an adult to tears, but not a child. The child's emotional range hasn't had a chance to be exercised and expanded.

Painters mature in a slow and natural way. So don't worry about starting late in art. I started late myself. You can start at thirty-five, forty or even later. It may take ten years to develop your skills. But nothing is lost, for you've still lived all those years. The painting you do five years from now can only be done five years from now. You can't rush it, and it can't be done tomorrow. I was as eager a student as anyone, and if there were any shortcuts, I'd have found them. I didn't, and I still haven't. In fact, I have more second thoughts and more struggles now

*Bright Morning,* 10″ × 20″

than when I was a student, simply because I've learned to demand more of myself.

The development of your particular mode of expression is also related to your development as a person. If you remember the importance of painting good pictures, of getting beyond the obvious and trite, and of seizing what you *like* in nature, then ten years from now your pictures will be more finished and complete than they are now because they'll say more about their subjects. Of course, when I use the word *more,* I don't mean your pictures will be full of detail. In the early paintings of Velasquez, you could see the cuticles of subject's fingernails. In his later paintings, you could barely see the fingers! His work became more elusive and suggestive—more like nature itself. His paintings were more finished, though they contained less detail.

To develop as an artist, you must constantly ask yourself, "What do I want out of painting?" It's easy to paint what everyone paints, but is that material really personal? A red barn, for example, is a common subject, and you have a strike against you when you paint it; people sense that they've seen it before. It's "approved" subject matter. Yet, if you can find a piece of nature and give it design and poetry, it will be *your* picture, expressing your own unique vision. You've seen the world in a different way and can give people a fresh and individual experience. I'd rather see one rock painted with sincerity and feeling than a canvas full of grand-opera effects. Making a "picture of things" is easy. But when you let people see the soul and drama of a subject, you've let them see it through the eyes of an artist.

# INDEX

# More Great Books for Oil Painters!

**Capturing Radiant Color in Oils** — Vitalize your paintings with light and color! Exercises will help you see color relationships and hands-on demonstrations will let you practice what you've learned. #30607/ $27.99/144 pages/222 color illus.

**Painting with Passion** — Turn your paintings into art as you learn to convey your deepest emotions on canvas or paper. Accomplished artists show you how to use composition, light, color, and value to suffuse your work with passion. #30610/ $27.95/144 pages/225 color illus.

**Welcome To My Studio: Adventures in Oil Painting with Helen Van Wyk** — Share in Helen Van Wyk's masterful advice on the principles and techniques of oil painting. Following her paintings and sketches, you'll learn the background's effect on color, how to paint glass, the three basic paint applications, and much more! #30594/$24.95/128 pages/146 color illus.

**Timeless Techniques for Better Oil Paintings** — You'll paint more beautifully with a better understanding of composition, value, color temperature, edge quality and drawing. Colorful illustrations let you explore the painting process from conception to completion. #30553/$27.95/144 pages/ 175 color illus.

**Bringing Textures to Life** — Beautifully illustrated step-by-step demonstrations will teach you how to add life and dimension to your work as you render dozens of textures in oils. #30476/$21.95/144 pages/500 + color illus./paperback

**Painting Flowers with Joyce Pike** — Popular artist/instructor, Joyce Pike, will help you make your florals absolutely radiant with 240 color illustrations and 15 demonstrations! #30361/$27.95/144 pages/240 color illus.

**Foster Caddell's Keys to Successful Landscape Painting** — You'll paint glorious landscapes with practical advice from this master painter. Plus, dozens of hints will help you solve (and avoid!) common painting problems. #30520/$27.95/144 pages/135 color illus.

**Basic Oil Painting Techniques** — Learn how to give your artwork the incredible radiance and depth of color that oil painting offers. Here, six outstanding artists share their techniques for using this versatile medium. #30477/$16.95/128 pages/150 + color illus./paperback

**Painting Landscapes in Oils** — Master painter, Mary Anna Goetz shows you the methods and techniques she uses to paint landscapes alive with light and color. #30320/$27.95/144 pages/200 color illus.

**Oil Painting: Develop Your Natural Ability** — No matter what your skill level, you'll develop you own style as you work through 36 step-by-step exercises with noted artist, Charles Sovek. #30277/$29.95/160 pages/ 220 color illus.

**Joyce Pike's Oil Painting: A Direct Approach** — As an oil painter, you know that one of the biggest problems is keeping colors clean and pure. Joyce Pike shows you how to overcome this problem and paint more beautiful oils. #30439/$22.95/160 pages/190 color illus./paperback

**The Complete Oil Painting Book** — Hone your skills and polish your oil painting techniques with the 32 step-by-step demonstrations presented in this comprehensive guide. #30111/$29.95/160 pages/256 color illus.

**Painting with Acrylics** — 25 full-color step-by-step demonstrations will show you how to tackle a variety of subjects from the figure to portraits and more! #30264/$21.95/ 176 pages/paperback

**The Complete Acrylic Painting Book** — You'll master the techniques of working in this beautiful and versatile medium with 32 detailed demonstrations and loads of helpful advice. #30156/$29.95/160 pages/256 color illus.

**Oil Painter's Pocket Palette** — Full color reproductions of an array of color mixes will help you choose the perfect colors to convey a sense of tone, mood, depth, and dimension. #30521/$16.95/64 pages

**Acrylic Painter's Pocket Palette** — 1,632 color mixes will help you pick the perfect mix without wasting time or paint! Each swatch shows you a dry glaze, a 60-40 mixture, the mixture tinted white and applied as a watercolor wash. #30588/$16.95/64 pages

**Enrich Your Paintings with Texture** — Step-by-step demonstrations from noted artists will help you master effects like weathered wood, crumbling plaster, turbulent clouds, moving water and much more! #30608/$27.95/144 pages/262 color illus.

**Enliven Your Paintings with Light** — Loads of demonstrations and examples show you how to sharpen your light-evoking abilities as you learn to understand light's principles and elusive qualities. #30560/$27.95/144 pages/194 color illus.

**Strengthen Your Paintings with Dynamic Composition** — Create more beautiful paintings with an understanding of balance, contrast, and harmony. #30561/ $27.95/144 pages/200 color illus.

**Dramatize Your Paintings with Tonal Values** — Your paintings will reach new dimensions as you learn to make lights and darks work in every medium. #30523/$27.95/144 pages/270 color illus.

**Energize Your Paintings with Color** — Create paintings alive with vivid color and brilliant light. Renowned artists and step-by-step instructions show you how. #30522/ $27.95/144 pages/230 color illus.

**Make Your Paintings Look 3 Dimensional** — Make your paintings jump off the page by adding that crucial 3rd dimension. Tutorials and mini demonstrations will help you develop a keen eye for seeing complex images and translating them onto the canvas. #30635/$27.95/144 pages